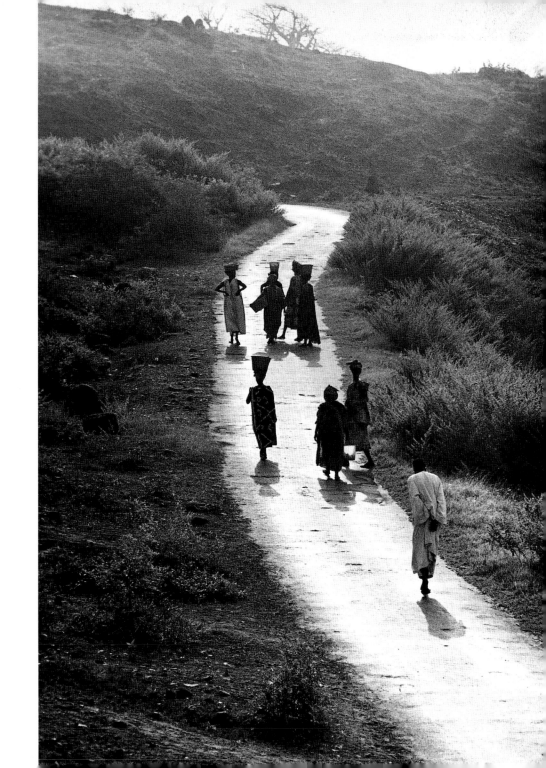

*T*HE VILLAGERS OF YOFF,
SENEGAL, RETURNING HOME
AT THE END OF THE DAY

ALSO BY CHESTER HIGGINS JR.

Black Woman
(with Harold McDougall)

*Drums of Life: A Photographic Essay
on the Black Man in America*
(with Orde Coombs)

*Some Time Ago: A Historical Portrait
of Black Americans, 1850–1950*
(with Orde Coombs)

*Feeling the Spirit: Searching the
World for the People of Africa*

Elder Grace: The Nobility of Aging
(with Betsy Kissam)

Doubleday

New York London Toronto Sydney Auckland

Echo *of the* Spirit

A Visual Journey

Chester Higgins Jr.

with Betsy Kissam

PUBLISHED BY DOUBLEDAY

a division of Random House, Inc.

DOUBLEDAY and the portrayal of an anchor with a dolphin are registered
trademarks of Random House, Inc.

Portions of this book have appeared previously—sometimes in quite different
form—in the following publications: "The Color Red" in *Essence,* "A Father's
Rite" in *The New York Times Magazine,* "Pilgrimage to the Past" in *Archaeology,*
"Down Home" in *The New York Times,* and "P. H. Polk and Me" in *Crisis.*

BOOK DESIGN BY MARIA CARELLA

Library of Congress Cataloging-in-Publication Data
Higgins, Chester.
 Echo of the spirit : a visual journey / Chester Higgins Jr. with Betsy
Kissam.—1st ed.
 p. cm.
 1. Higgins, Chester. 2. African American photographers—Biography.
3. Photographers—United States—Biography. 4. Higgins, Chester—
Philosophy. I. Kissam, Betsy. II. Title.

TR140.H47A3 2004
770'.92—dc22
[B]
 2003067482

ISBN 0-385-50978-2

PRINTED IN JAPAN

November 2004

First Edition

10 9 8 7 6 5 4 3 2 1

 To Bernest Brooks,

*my high school social studies
teacher and Boy Scout master of
Troop 84 at Warren Smith High
School in New Brockton, Alabama.
He became a second father to me,
helping to direct my passion for
history, people, and politics. I'll not
forget his profound exasperation
when he told me, "Chester, slow
down! You've got the body of a
Model T Ford with the speed of
a V8 engine." From him I learned
much. I didn't slow down, but
with his guidance, I learned to
focus my energy.*

Contents

Within *the* Blood

Water *of* Change

Acknowledgments

I wish to thank Odjidja Ablorh, Joel Baldwin, Tony Vaccaro, Cecil Brock, Elma Brock, Mayor Charles Cole, Kirkland Douglass, Suzanne Goldstein, R. P. Flowers, Lenwood Herron, Sameh Iskander, Judith Keller, Elizabeth Kissam, Danny and Nell McGaffie, Barrie Novak, Cheryl Polk, Grace Rothstein, Johnny Frank Smith, Julie Johnson Staples, Tucker West, and Delphine Williams for their encouragement. Many thanks to my editor, Janet Hill; my agent, Sandra Dijkstra; and her staffer Babette Sparr.

Finally, thanks to Igor Bakht for his wonderful prints.

And there appeared a
great wonder in heaven;
a woman clothed with the sun,
and the moon under her feet,
and upon her head a crown
of twelve stars.

—Revelation 12:1

rologue

This is a story about my life as a photographer, my growth as an artist, and my search for individual and collective identity, and about how the Spirit has come to influence this process. Photography is my tool to discover and acknowledge the echo of the Spirit. I never sought the Spirit. Quite the contrary. The Spirit inserted itself into my life in a vision in the middle of the night when I was only nine years old. My grandfather interpreted my experience as a calling to the ministry. Because of him I embraced religion, and for the next decade, under his tutelage, I took to the Scriptures like a fish to water. But he passed away in 1959, when I was thirteen years old, and much of my resolve died with him. No other minister seemed able to match his moral fortitude. I became disillusioned with what I saw as the hypocrisy of some of my fellow ministers, deacons, and church members. I no longer wanted to be responsible for the spiritual maintenance of congregants.

In 1964 I went away to college. By not revealing my ministering history to my classmates, I shook off my responsibility to the Spirit. I gave it little thought for decades. But like a star below the horizon, it hovered just out of view. It was many years before I would rediscover its presence.

After college, at the age of twenty-two, I traveled to Africa. On that first trip, a seer in Ghana did a reading for me, using a collection of bones and roots. Some fifteen years later, I had a second reading, this time in Brazil, with cowrie shells. During both readings, the Spirit refused to be still. I remember being told there was something I must do for the Spirit, which was not at all what I wanted to hear. I found it troubling, for it conjured up what measure of guilt I had for relinquishing my obligations to the ministry.

In 1992, when I was forty-six years old, I let myself be convinced to undergo yet another reading, in Haiti. Even though the message was translated (the priest spoke no English, and I understood neither French nor Creole), the words still stung: "There is something that the Spirit is waiting for you to do." Without thinking, I reacted immediately and violently. The priest was in a trance, but I was shouting uncontrollably: "I don't want to hear this! I've done the Spirit's work! It's in my past." While my words were being translated, I watched a clear sky abruptly darken with thunderclouds and flash with lightning, but the priest remained placid. "Yes," he said at last through the translator, "the Spirit says there is something you must do, but you don't have to pastor a church." Still in a trance, the priest said, "You decide how. The way will come to you."

Although that reading brought me a modicum of relief, the priest's prophecy didn't reveal itself until a few years later, when I was culling three decades of my photographs for the publication of my fourth book, *Feeling the Spirit: Searching the World for the People of Africa*. As I looked over my pictures, I realized that unbeknown to me, the Spirit had remained a constant partner in my life, my work, and my thinking. On my voyage of self-discovery I had become a different kind of evangelist on another kind of crusade.

My years as a childhood minister illuminate the passion I bring to my photographic mission today. After choosing the camera to be my instrument to confront and embrace my reality, I pursued photography with zeal. I set out to record all things dear in the life and culture of people of African descent—the same people to whom I had once ministered.

Whenever I make a photograph I try to capture the signature of the Spirit. Unseen, but ever manifesting itself, the Spirit sustains and enriches what is inside everything. The Spirit informs my daily living.

Chester Higgins Jr.
Brooklyn, N.Y.
2004

 *M*Y HOME IN NEW BROCKTON, ALABAMA

hosen *by the* Spirit

My first understanding of spirituality came through my grandfather, the Reverend Warren Smith. He was a Southern Baptist minister who built and pastored three churches in rural Coffee County, Alabama. An unassuming man, he was gregarious, attentive, and smart, with a welcoming smile and a kind word for everybody.

When I was nine, in 1955, my life, however ordinary it may have seemed up until then, was irrevocably changed. I went from being a naughty kid to being a serious holy "man" who preached at different churches and recruited members into the Southern Baptist Church. My peers became wary of me, while adults sought my blessing.

One night I was asleep when, at about 3 A.M., a low, constant sound within my head awakened me. I opened my eyes and saw a supernaturally bright light coming from the wall diagonally across from my bed. This was not a dream; dreams happen while one sleeps. I sat up. I squinted, searching the strange light. Over six feet in diameter, it

My great-aunt Shugg Lampley praying before going to sleep

2

pulsated, radiating from its center. It was strange and new, but it held no fear for me.

As I studied the light, the center cleared, revealing the image of a man draped in a garment as in ancient times. It was standing with eyes closed and hands held palms up at waist level. After a moment, its eyes opened— light brown eyes that looked at me with an intensity I had never known before. It began to walk very slowly toward me with those outstretched hands. The room rattled with crackling energy. Who was this being coming toward me? Could it be an alien? But my spirit assured me it was safe.

When the figure was less than six feet from me, the sounds of tinkling gave way to a voice: "I want you." Then terror took over. My own screaming voice filled my ears. Death was coming for me. I didn't want to die. I screamed louder.

Four adults burst into my room. My mother was first to reach me; over her shoulder my father appeared, and next to him my grandparents. Someone pulled the chain of the light fixture suspended from the ceiling. In that instant of exploding electric light, the supernatural brilliance and the man disappeared. I saw four people at my side; I felt the hands of my mother, but I continued to scream uncontrollably. Was I dying and was this the moment of death, or were these faces around me real, part of the world of the living?

Their continuing questions about my "nightmare" assured me I was not dead, and I became calmer. I recounted what I had seen, how the air rattled with energy and what the man had said and done. Everyone except my grandfather, Reverend Smith, was baffled. He was certain I had just had a vision calling me to the ministry.

MORNING STAR BAPTIST CHURCH, WHERE MY GRANDFATHER, THE REVEREND WARREN SMITH, PREACHED

Grandaddy Warren

CHAPTER TWO

A man of average height, stout, balding, and clean-shaven except for hair growing out of his ears—that's how I remember my grandfather. He was an accomplished tailor, the owner of our dry-cleaning business in New Brockton, Alabama, as well as the minister of three churches. A ready smile matched his cheerful disposition. Everyone loved him, and he loved them.

Until his death, Grandaddy's guiding hand helped chisel the milestones of my life. He interpreted the vision that had snatched my sleep, certain that it had been a call to the ministry. Indeed, I preached from the pulpit for over a decade in Alabama.

Grandaddy gave me my first driving lesson, when I was eight years old. He did this even though I had forced his car off the road during a hard rain a year or so earlier. I was sitting next to him in the front passenger seat when the car skidded on a patch of mud. We were sliding downhill across the road. Watching him fight with the steering wheel, I

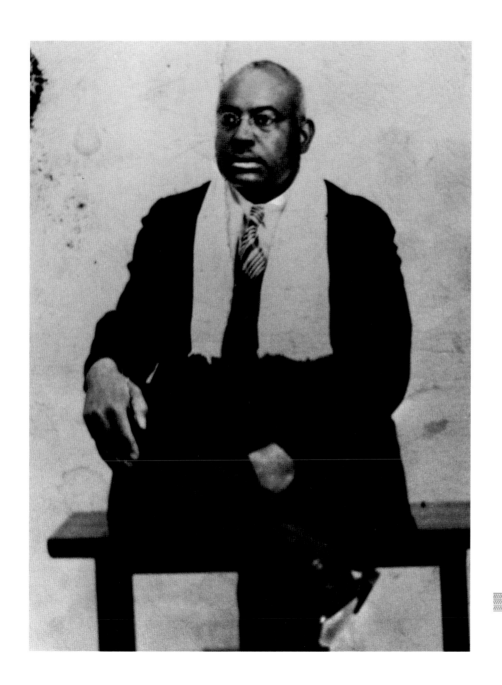

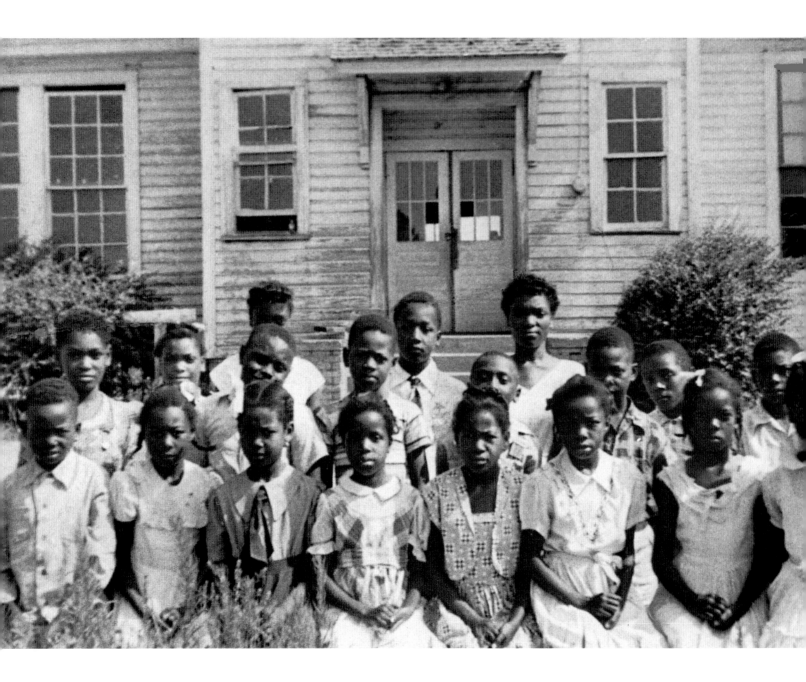

thought my grandfather must be having a heart attack, so I grabbed the wheel to straighten us out. Abruptly the car left the road, and we landed in a ditch. No one was hurt, and after his initial shock my grandfather was more amused than angry.

It was Grandaddy who taught me how to knot a suit tie. I stood in front of the mirror working the tie as he sat at his sewing machine making clothes in his dry-cleaning shop, while my father worked the presser. After watching numerous tie-tying failures, my grandfather stood up. "Let me help you" was all he said. Untangling the tie, he explained the knotting sequence while he guided my hands on the fabric. And then he let me do it by myself. I remember touching the precious knot before trying to retrace the steps he had just shown me. I looked in the mirror and then at him for reassurance and, when necessary, direction. It took a few tries, but I got it. Thrilled, I strutted around the shop displaying this knot of my own making. Grandaddy gave me his congratulations, laughing with pleasure. Then he went back to his work.

It wasn't until I became an adult that I discovered that this gentle man, whose strength was always there for me, had been a staunch pioneer for the improvement of the lives of all African Americans. He had withstood racial slurs and threats and had even had his house burned down during his struggles to secure voting rights and schooling for African Americans in Coffee County.

Before 1928, powerful landowners were able to mandate that only white children would be educated in the county. My grandfather, Reverend Smith, petitioned the county board of education to pay

A PICTURE OF A CLASS OUTSIDE THE NEW NEW BROCKTON COLORED SCHOOL IN 1955

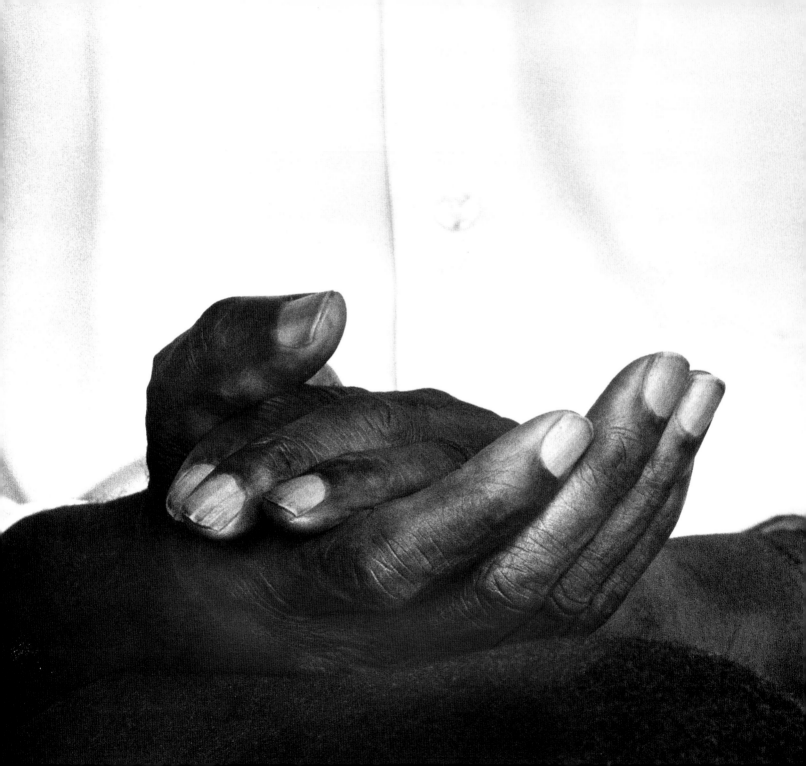

*T*HE BUILDING WHERE MY
GRANDFATHER ESTABLISHED HIS
DRY-CLEANING BUSINESS

teachers' salaries if he provided the land and the building for our school. They agreed, and he converted our Masonic Lodge to accommodate five classes on two floors. The nearby Collins Chapel A.M.E. Church served the overflow. Grandaddy headed the search committee that found the first teacher, Mr. Paul Anthony Youngblood.

The county school board soon donated to New Brockton an abandoned school building in another part of the county. It was up to our community to move it. My grandfather, with help from other school trustees, organized the community to salvage the lumber and straighten nails from this old building. Two carpenters, Mr. Milton Yelverton and Mr. Les Flowers, were hired to organize and instruct all the volunteers. This band of dedicated citizens constructed our first school on land owned by my grandfather.

In the 1930s, voting was still very much a rich man's sport in rural Jim Crow Alabama. To vote, you had to own property or, failing that, pay a poll tax every time you voted. Along with other African American landowners, my grandfather took folks by the carload to the polls on voting day and paid their tax so their voices could be heard.

My grandfather's genuine and positive spirit proved to be a powerful and inspirational catalyst for change.

In the Spirit of King

We lived on the edge. Growing from childhood to young adulthood as an African American in the state of Alabama had its moments of joy and times of terror. Forced to live separately, black people could find happiness and solace only among themselves. In our own company, a certain element of normalcy was enjoyed. In the company of whites, however, uncertainty and tension filled each moment. Tension could turn to terror instantly. It was like being in a cage with a rattlesnake and not knowing when the snake would attack. There was the ever-present possibility of instant death by white criminal behavior, protected by the privilege of skin color. The very presence of a white person among us held the possibility of being killed.

Our ability to express ourselves freely could invite revenge from the local white people. Control over our lives was limited to our own barbershops, funeral homes, churches, and schools. Jim Crow laws locked us out of public accommodations and prohibited free expression.

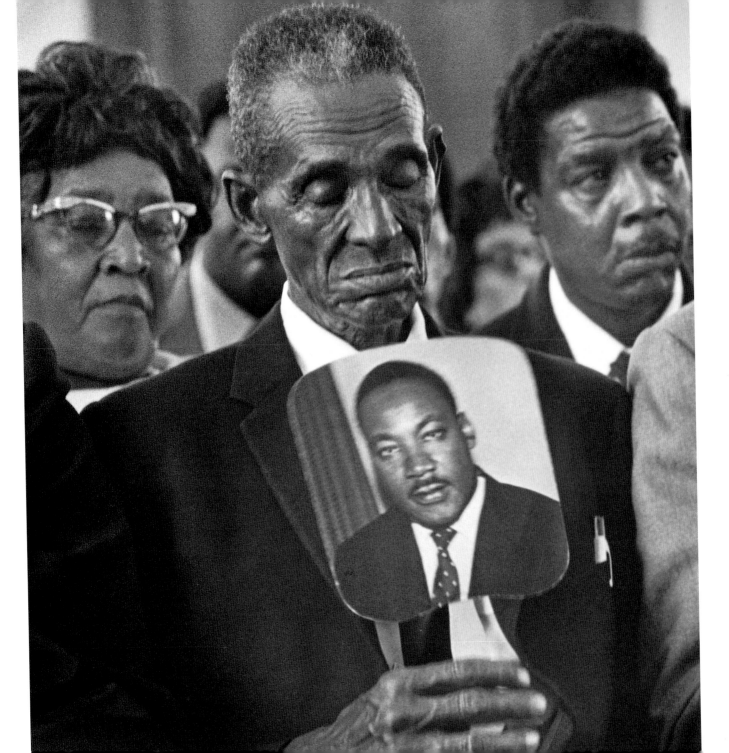

Poll taxes, civics tests, and threats restricted and eliminated voting privileges. We were visible punching bags.

Life shared with fellow blacks was precious as we found the protected space to enjoy ourselves. In the Bible, many found the peace to face adversity and, if necessary, death itself.

In this environment, the voice of Martin Luther King Jr. in the late 1950s and early 1960s brought us hope that things could change for the better. Dr. King stood and spoke directly to the powerful politicians in our state and aired their dirty laundry in public—before their eyes and the eyes of the nation. In his sermons, he judged whites as equals and declared them guilty of racial terrorism.

In the twentieth century there had been no one to rally the terrorized black population of Alabama, and Dr. King took up the cause. Whenever he was on radio or television, every black person would listen. At the sight of him or the sound of his voice, some would fall on their knees or raise their arms to the sky. A lord of deliverance had come. Finally God had sent a Moses to be among us and bring His people out of the bowels of white civilization.

Dr. King's voice for equality was seconded by those of the Kennedy brothers, John and Robert. All three of these men were silenced by assassination. Images of Dr. King were displayed in revered places in the households of southern blacks. After the assassinations, there appeared a composite portrait that grew almost as popular. Images of King, Kennedy, and Kennedy, the three Ks we blacks embraced, became silent shrines in each home, church, or place of

An image of Dr. King on a fan in a church in New Brockton

A COMPOSITE PORTRAIT OF
JOHN F. KENNEDY, MARTIN
LUTHER KING, AND ROBERT
KENNEDY ON THE WALL OF A
BARBERSHOP IN TUSKEGEE

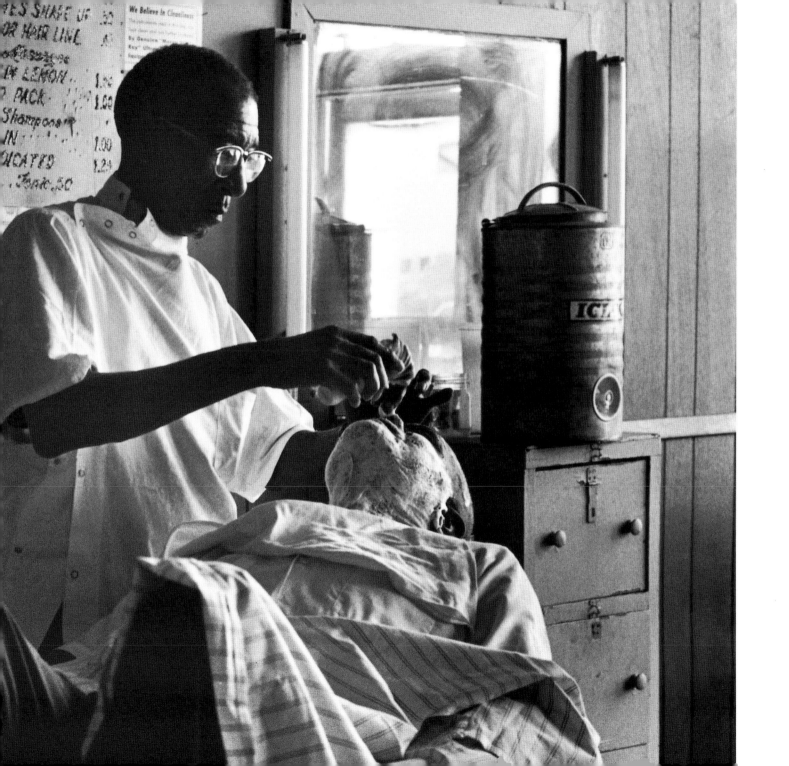

business. These men were our friends. We loved them for what they stood for and were in mourning for our loss.

Like the rest of my people, I acknowledge the sacred presence of Dr. King's life and work in our lives. He left behind a memory, an inspiration that remains beyond his grave in our hearts. His living among us, standing up for us, inspired us all to rise up with him.

When I was a student at Tuskegee University in 1968, I photographed a local barber in his shop. He too had an image of King in his life as he carried out his daily labors. He and his customers found reassurance in the presence of this image, which triggered their memories, their hopes, their pride, and their determination to continue.

My own activism during college, marching against George Wallace at the state capital, motivated me to become a photojournalist. I took note of the pictorial coverage of the students showing up in Montgomery, advocating for equal rights—American citizens exercising our constitutional right to petition our government for change. But the news photographers represented us as thugs and potential arsonists.

I discovered firsthand that our story was being marginalized and corrupted by outsiders' version of hate. It became clear that I needed to make photographs from the inside. These images would show what outsiders couldn't—or refused to—see. Nowhere were the elements of decency, dignity, and virtuous character recorded in photographs of African Americans. These significant elements of our humanity are even today all too often beyond the reach of many outsiders who photograph people of color.

To Kiss *the* Memory

CHAPTER FOUR

They came during the summer: two teenage girls with beautifully smooth brown skin, who came from Detroit with their father to my southeastern Alabama hometown. Those girls were really cute, and this was their first time out of Detroit into the South—the country. Their father had not been back home since they were born. He had come to visit his mother and have his daughters get to know their grandmother.

I had a crush on the older one. I loved sitting on her grandmother's porch, listening as her words painted pictures in my mind of a mysterious faraway place called Detroit. Their grandmother, Aunt Jessie, who lived with her sister Ola, was beside herself with glee at their visit.

Aunt Jessie was in her sixties; Aunt Ola seemed older. They lived in the house across from the Springfield Baptist Church, at the junction of the street that went to town and one that came to a dead end in what

we called "the Bottom." Aunt Jessie was a favorite of all the children because she sold candy from her house. We loved her dearly. But come Sunday we made a point never to sit behind her at church. She was one of those ladies who would come to church, fill up on the Gospel, and get happy. This caused her to go into a semiunconscious state and fall backward, with all her 250 pounds, crying for the joy of living in the Spirit.

Our town—two blocks long, with ten stores, one restaurant, two gas stations, the First Baptist Church, the Piggly Wiggly Supermarket, and the post office—really was a village. Its commercial district sat at an intersection on Highway 84 where the one traffic light hung.

One day after the girls had been to the post office to mail letters to their friends back home, they stopped into the restaurant to get ice cream cones. The waitress told them that she couldn't serve them. They left, perplexed by the strange refusal. They put it out of their minds and walked down the dirt road back to their grandmother's house.

We locals knew never to go to the front door of this store. The man who owned it was a Klansman and would serve black people only at the back door. He was also the town policeman.

As the girls walked back, the policeman, accompanied by his son, caught up with them in his car as they were coming around the last curve before their grandmother's house. I had just spotted them when the two men sprang from the police car, stunned them with tear gas, and attacked them with batons. I watched from the distance in the company of a few shocked adults. The policeman and his son then

CHASING BUTTERFLIES

OVERLEAF: *A* COUNTRY ROAD IN ALABAMA

20

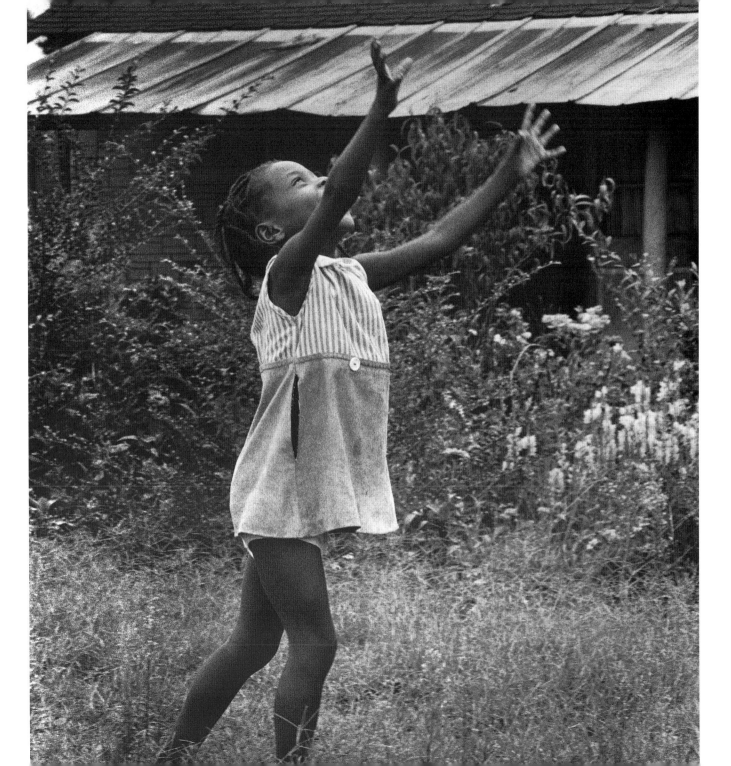

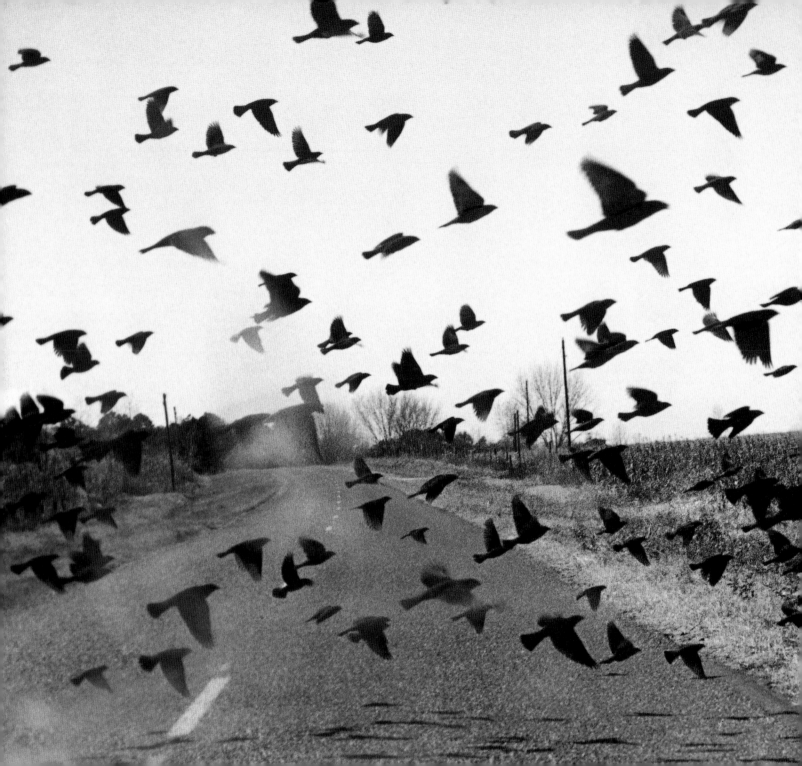

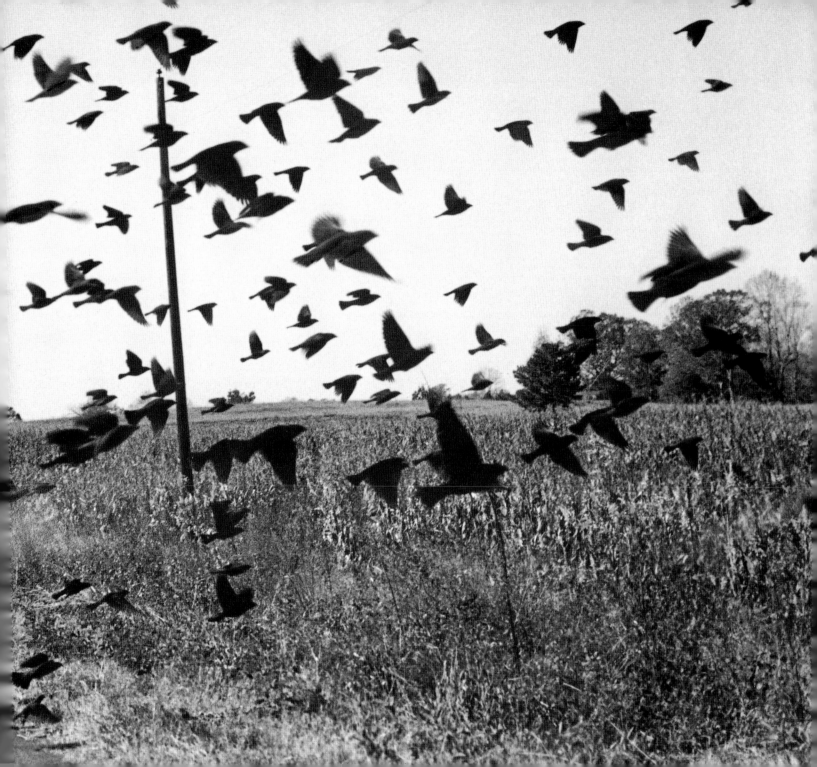

threw the girls into the back of the car, drove back to town, and put them in jail.

Word spread quickly from house to house along the road. Seven older women gathered on the girls' grandmother's front lawn. They waited while someone went inside to tell Aunt Jessie and the girls' father what had happened.

Yells went up from Aunt Jessie and Aunt Ola. The father, filled with rage, ran out the door and bolted from the porch. To my surprise, old Aunt Jessie, who had never been known for moving fast, was right on his heels. Then the strangest thing happened. The women at the edge of the lawn ran toward the father and locked arms with Aunt Jessie to block him inside their circle. He kept screaming for his right to get his daughters. The women, certain the evil policeman would kill him, pleaded with him to let them handle it.

His attempts to leave thwarted, the father finally fell to his knees and let out a piercing, heartwrenching howl. There he was, howling on the lawn, locked in by eight older women. And they were both right—the father to want to get his girls and the women to contain him for his own protection.

Once the women were satisfied that he wouldn't go to town, Aunt Jessie went to the jail to get the girls released. She returned with them. The father embraced his daughters as if they had just been rescued from a swollen river. They all cried.

The girls and their father left a couple of days later, cutting their month-long visit to a week. The night before they left, I sat on the porch

with the older girl—the one I had a crush on. I don't remember saying anything to her. There was nothing I could say to express my sadness, my anger, my shame.

But I do remember what she said to me as she got up to go inside: "I don't want to be black anymore. From now on, I'm going to be an East Indian."

Down Home

Each fall after harvest, my grandmother, Faith Smith, and several of her friends turned to patching quilts and gossiping in her living room. Outside, relegated to the porch, the men shelled peanuts.

It was a time of furious activity. First the men pushed the furniture to the fringes of my grandmother's living room, and then in the center they set up a quilting frame made from two wooden sawhorses connected by two straight boards. All summer long the women had collected torn and tattered clothes, sheets, and bedspreads in preparation for this moment.

With the frame in place, the women set to work stretching a lining for the quilt. But the fall ritual didn't officially begin until my grandmother's husband, Reverend Smith, arrived with a sack of cotton in the back seat of his car and several bigger sacks filled with raw peanuts in the trunk. The cotton came from the local cotton gin and the peanuts from neighboring farmers, who needed help separating the nuts

from the hulls for next season's planting. The men worked outside under the covered porch, tossing shells and nuts into separate pails set out by the women. The living room was the women's temple.

Shelling peanuts was tedious work, so I would dash inside the house whenever I could to see how things were coming along with the quilting. I was still young enough—barely seven years old—to pass unchallenged into this sacred feminine domain. I loved observing the women bent over the quilting frame with thimbles, moving needles frenetically. Watching the stitches become pieces and the pieces become portions was pure magic. Just the sight of the women working drove back the imminent winter cold.

At the end of an afternoon of work, the men would roast a few peanuts for all of us to enjoy and the women would make lemonade and break out the homemade cakes they brought with them each day. We all sat together on the front porch, enjoying the last rays of sunshine.

Days would pass this way, until the day the women would take the quilt off the frame, admire it, fold it up, and then begin anew. They always made as many quilts as there were women in the group—one for each. Weeks would go by before they finally finished all the quilts.

During one of my intrusions into the female bastion of the living room, my "open ears," as my annoyed older cousin Elma Brock referred to them, caught a morsel of conversation about one of my great-uncles, a brother of my grandmother's. He came from a family of fourteen children. The first child, a girl, arrived around 1880, but her father was disappointed. Nine years and six girls later, he was still hoping for a boy. When the seventh child miraculously turned out to be a boy, he was so

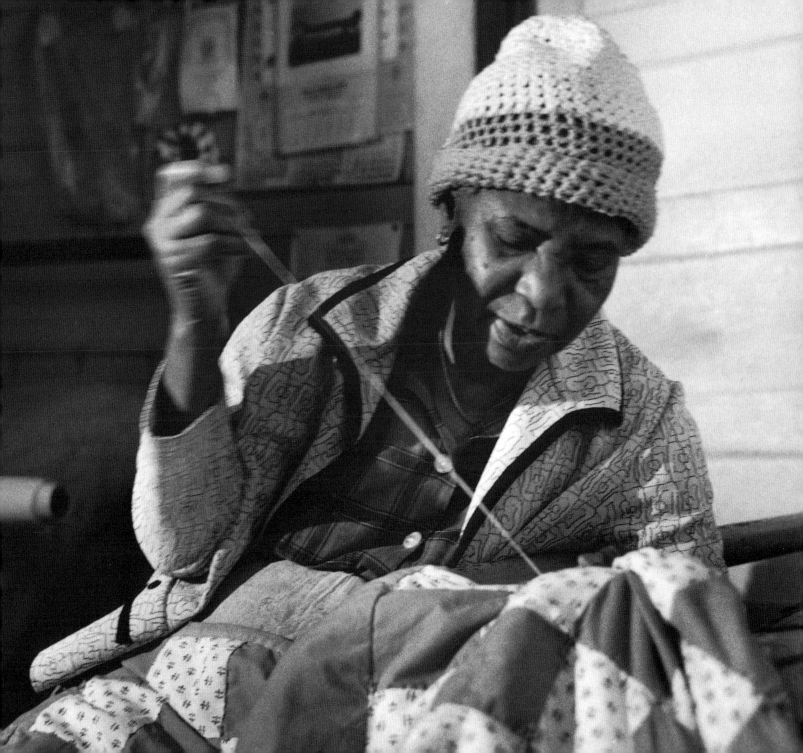

excited he gave his child all the names that he had planned to use for the sons who had been born daughters. My great-uncle's birth certificate reads Gabriel Guster Preston Brown Elijah John McGowan, but everyone called him John for short.

As soon as I heard this story, I committed all the names to memory. My good-natured uncle always laughed at my singsong repetition of his long name.

One by one, the women in my grandmother's quilting session passed on. My grandmother and grandfather also died. My mother preferred crocheting to quilting. It seemed as if quilting died with them in my small Alabama village.

Decades later, my research into African American arts rekindled these memories, and I wanted to photograph quilting before the craft disappeared. My mother was still living then, and she helped me find some quilters. It wasn't easy, but finally she found quilters in a nearby rural Alabama hamlet and I went South in the fall—the patching season.

My visit with the group took me back to the comforting years of my youth. Once the women had placed me in my family history and connected me to people they knew, they brought me up on the latest news. And for a brief moment I found home again.

A QUILTER IN SHILOH, ALABAMA, A FEW MILES FROM NEW BROCKTON

That Childhood Friend

In many ways, Andy Harris and I had much in common. We were both only children. His father was the postmaster of my hometown, his mother a homemaker. My father ran our family dry-cleaning business, and my mother was a schoolteacher. Both of us liked people, and we enjoyed each other's company.

Andy was popular and friendly. When he wasn't riding his motorbike around town, he invited his friends to play basketball with him in his parents' backyard. On very hot days, his mother served lemonade. If I happened to be passing his house, I was sometimes invited to join the noisy gang in his yard. Next door to Andy lived a family of sharecroppers; their three children were friends of mine from school, and the reason I went by.

Although we grew up in the same small village of eight hundred people, Andy and I lived in separate worlds. Unlike me, Andy is white.

My backyard swings and basketball hoop enhanced my popularity with the kids on my side of town. My nearest friends were the Simmons children; I had only to walk through my grandfather's pecan orchard to visit Levi Simmons. Along with Levi, four other children— Sonny, Kunai, Betty, and Helen—still lived at home. Although not sharecroppers, the family struggled under similar financial pressures. Every summer all the Simmonses hired themselves out to work for the local farmers to repay the debt the family had incurred at the town store; throughout the rest of the year they survived on credit.

Nearly all my friends worked harvesting farm crops in the summer. For me, because of my parents' income, working in the fields was an elective, and I was committed already to helping my father on Saturdays at the dry-cleaning business. By the time I was ten years old, summers by myself had become tedious. My mother would come up with more chores than I believed were physically possible to complete in a day. And I was really bored without my friends, so I joined them doing fieldwork. At least that way I could be in their company.

Picking cotton was the job most readily available to preteens. This meant rising before dawn and returning home after sunset; pickers prefer to start when the plants are still wet with dew, believing that the water makes their first sack of picked cotton heavier. (Payment is by weight). Every morning after breakfast I left home with a couple of sandwiches for lunch and money for a soda. I would race to the Simmonses' in the dim predawn light to catch the truck that always stopped in front of their house. I enjoyed standing in the back of the

truck, hanging on to the side slats, feeling the fresh, moist morning air hit my face as we rode to whatever farm needed workers that day.

The Simmons children, having spent nearly all their summers doing fieldwork, were much better at it than I was. Because I wanted to stick close by them, I suffered under the barking demands of their mother, Polly Simmons, to work harder. While Levi and his sisters picked two rows of cotton at a time, it took all I had to keep up while working just one row. They could each pick a couple of hundred pounds of cotton a day, but my average never topped fifty or sixty. On my first day, Mrs. Polly made it clear that I was to be left behind if I couldn't keep up. She was right. They had bills to pay. My mother allowed me to keep the money I made, encouraging me to save it to buy new clothes for school.

Where we picked depended on which farmer stopped at the Simmons house. One week we found ourselves on the outskirts of town near my friend Andy's house. Sometime that morning Andy passed by on his motorbike, heading to town. When he returned, he saw me in the field and we waved. Later that afternoon Andy came over to chat with me while I worked. When I had filled my sack with cotton, Andy went with me to the wagon in the middle of the field where the farmer weighed all the picked cotton.

After my sack was weighed, it was thrown up into the high-walled wagon to be emptied. Andy took advantage of the moment to climb into the wagon and enjoy the sinking feeling you get from walking on top of loose cotton. As I waited for the farmer to throw down my empty sack, I measured out a ladle of the cool water kept by the wagon for pickers.

All the while other pickers headed to the wagon with their cotton. The sacks were emptied quickly; farmers made sure that workers wasted little time getting back to work.

One of the pickers that day was a poor white boy, not from our town. For some reason he focused on me, shouting *Nigger*. I froze—not only insulted but stunned. Interaction with poor white laborers was limited in the fields, as whites generally chose to maintain a degree of segregation by working rows far away from black pickers.

Part of me wanted to kick in the boy's face. He was dirt poor, nobody. *But* white. In the racist South, his skin color gave him the right to look down on any black, and in that moment I became *any* black. Feeling unable to retaliate—fearful of adult retribution to me and my family—I moved to escape. My only option, I believed, was to ignore his anger and get away as fast as possible.

But before I was able to collect my empty sack, Andy jumped from the top of the wagon onto the boy, pinned him to the ground, and began to hit him. As my friend, Andy did a great thing in punishing this kid. He could fight with another white boy with limited consequences to himself. But because Andy beat him for insulting me, I had tremendous anxiety that the boy or his friends, seeking revenge, would attack me, or even my family, when Andy was not around. Still reeling under the racist insult and the surprising act of friendship, I went back to work without so much as a word to Andy.

Today I accept that it was fear that caused me to cut myself off from Andy, my only white childhood friend. His protective attitude in

our racist 1950s environment caused me as much anxiety as the other boy's hatefulness. I respected Andy for his action, but after that moment in the cotton field our friendship ended. I spoke to no one about that afternoon. I felt trapped and needed to escape from both white boys— my friend as well as the one who hated me.

Measuring Up

In my school there were twenty students in the seventh grade. I was the shortest boy, and at that time in my life, my height—really, the lack of it—kept getting in the way. The summer before I started seventh grade, all the boys grew except me. For a couple of years I had been anxiously watching the measuring tape on the wall in my house, and I was stuck at four feet eleven inches. Desperately I wanted to reach five feet, but I feared I was destined to remain just under for the rest of my life. In seventh grade, that meant not being selected when teams were chosen to play basketball, and it spelled almost certain disaster for romance. In the 1950s, girls just didn't date shorter boys.

In spite of my "teenage" appetite, as my mother called it, I was not growing. That summer I worked in the fields harvesting cotton, peas, and tomatoes. Picking cotton is backbreaking labor; the plants are never taller than three feet, so you must bend to pull the cotton from the many open bolls hanging on the branches. Men usually work on their

knees, but unless the ground is sandy, walking on your knees becomes punishing in a very short time. But the men taught me to make miniature pillows of cotton and tie them to my legs to make kneepads. In the cotton fields, Levi Simmons and I instinctively moved together to meet some of the cute pickers from "out country." When we spotted a pair we were interested in, we'd choose a row next to theirs and begin catch-up. No one started a row in the middle, so we had to hustle if we were going to reach them and establish contact. During those frantic rushes, I became acutely aware of how much longer Levi's arms had become than mine. He was able to kneel in one place and reach more cotton bolls than I could. It seemed like I was moving constantly—not an easy or graceful task on one's knees.

If that wasn't bad enough, one day Levi told me he was "moving up" to stacking peanuts. Only those with arms that were long and strong enough could harvest peanuts, and they made more money than those left behind to pick cotton and vegetables. After machines dug up the peanut vines, laborers swarmed onto the fields with pitchforks to toss the vines up over wooden structures to dry. The first hoists, over the low crossbars nailed to an eight-foot-tall pole, were easy. But as the pile of vines grew, so did the strength needed to reach the top of it. When you are under five feet, the point at which you are lifting over your head comes quickly—too fast for farmers to consider hiring you. Levi, who was nearly a foot taller than I was, had it made.

The night before school started, I checked the measuring wall. No change, in spite of a whole summer of fresh air, sun, physical labor, and lots of food.

THE SEVEN BOYS IN MY HIGH SCHOOL GRADUATING CLASS OF TWELVE STUDENTS (I'M ON THE FAR RIGHT)

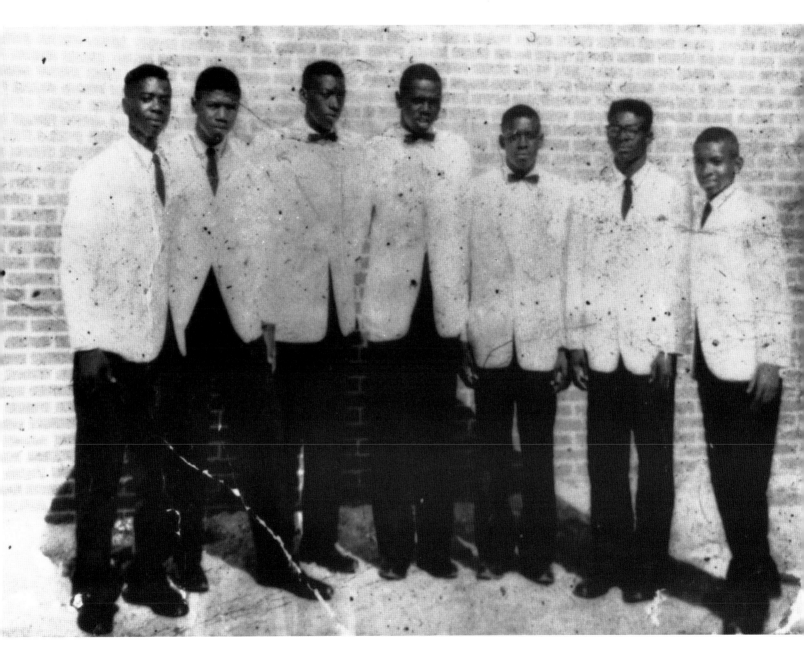

The first day in my seventh-grade class I sat in the only available seat, in a middle row. I managed to walk in just as our teacher, Miss Eloise Jackson, was calling my name. But before I could answer, she interrupted.

"Chester, why are your shoes smoking?"

"Oh, that. That's the fertilizer I put in them."

"Fertilizer?" she repeated. And after a pause, "What for?"

So I told her I was tired of being only four feet eleven inches tall. That I wanted to grow. I said that since fertilizer made plants taller, I thought maybe it might help me too.

Snickers and giggles erupted all through the class. How could everyone be so sure I was wrong?

There was no smile on Miss Jackson's face. Glaring at all of us, she told me to go outside and empty the fertilizer from my shoes. By the time I got back, the morning lesson had already begun. I sat down and opened my book to catch up.

For the rest of the day, no one mentioned fertilizer to me. It was as if the whole incident had never happened. Not until forty years later, on one of my trips back home, did someone remind me of that morning— and tell me what really happened when Miss Jackson sent me outside to empty my shoes. She sternly instructed the entire class not to pick on me or whisper a word to anyone outside our classroom about what happened on that first day of seventh grade.

I seriously doubt that all the kids in my class held their tongues, but I can vouch that no one spoke about it in my presence.

A Declaration *of the* Self

CHAPTER EIGHT

As a college sophomore, I remember voicing fears for my future to my great-uncle March Forth, who by then was pushing ahead through his seventies. He listened attentively, probing and guiding me through what I defined as my options, and then finally he offered a piece of advice that has become my credo. "It's important to make a mark on life," he told me as we ambled through his plentiful garden and he plucked ears of corn for supper, "or else you could very well die, undeclared."

The notion of declaration took on new meaning for me thirty years later, when I was photographing at the bedside of a dying woman. We came together, this eighty-six-year-old painter and I, for mutual benefit. I wanted to capture her very wise countenance and to understand this extraordinary woman, who projected peace in the face of imminent death. I believe she enjoyed the stimulation of sharing ideas with another artist, even while life was slipping away from her. All she asked of me was one tangible—an obituary photo, which I was honored to make.

During one of our visits, I probed gently into the line of thinking that sustained her in the presence of death, and she told me simply that she was content. She would be leaving behind "monuments" to her being. Thinking I understood what she meant, I acknowledged her lifetime of creativity—artworks preserved in private and public collections and reproduced in books: a noble declaration.

"No," she corrected me, "that's not what I'm referring to at all. I mean the relationships I've made with people throughout my life. My relationships will continue and branch out. These are my living monuments."

Wisdom *of* Age

CHAPTER NINE

Wisdom can be a welcome companion of old age. Those who find wisdom become the beacons for the rest of us. We are attracted by their peacefulness and the vast reservoir of understanding they have acquired through years of living. As enigmatic as it seems, wisdom is clearly recognizable. We see it, we feel it, and we want to be part of it.

In my hometown, all older people were respected, but those with wisdom were cherished. They almost always moved slowly enough for youngsters to sidle up next to them and hang out, and even, after a while, to interrupt to ask a question. Most often I'd just listen.

When I was a child, my favorite male relative was my great-uncle March Forth McGowan. As a youngster, I spent long hours with him, night fishing, hunting, making syrup from sugarcane juice, working in his garden, and sitting on his front porch listening to his musings.

On one particularly warm, lazy Saturday morning I set up a game of marbles within earshot of my great-uncle Forth and his brother, my

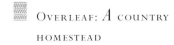 OVERLEAF: *A* COUNTRY HOMESTEAD

41

great-uncle John. Their conversations were a steady source of wonderment for me. They held court in their favorite weatherworn chairs outside my grandfather's dry-cleaning business. For a remarkable minute that day, I was their topic of conversation. Without looking up, I knew from the way their voices projected that they were looking in my direction. "Energy," one of my great-uncles said, "is wasted on youth. If only I had my wisdom with his energy." Then they tipped back their rickety chairs and enjoyed a long, leisurely laugh.

Although not thrilled to be the butt of their joke, I still felt special, knowing I had something they both valued. There was no way I would have given up my flexible young body, but I also recognized that my two great-uncles weren't advocating abandoning the quality of mind I so admired and desperately tried to emulate. But I was mystified. For me, there was still time to acquire what my uncles had; for them, the quickness of youth was a memory. And yet they clearly were just fine with that.

Wisdom, I discovered that day, encompasses the ability to see things clearly—to accept reality and be more than comfortable with how things are.

Burial Wedding

I first became aware of Great-uncle March Forth McGowan when I was about three or four years old. My mother would leave me from time to time with him or his sister, my great-aunt Shugg Lampley. I recognized him as much by my nose as with my eyes. He smelled of the Prince Albert tobacco he rolled into cigarettes and the Bull of the Wood chewing tobacco he was equally fond of. Even Aunt Shugg was perfumed by tobacco; she dipped snuff, something nearly all the women of her generation indulged in.

One day while I was playing on Uncle Forth's porch, he sat on the edge smoking and watching me. After a while I interrupted myself to go inside to urinate. When I came back, I had forgotten to zip up the fly on my pants. Uncle Forth reminded me to zip up and then admonished me, saying "my horse would escape." I zipped and continued playing.

A while later I went in to use the bathroom again. Rushing back outside, I continued my play. What I didn't realize was that I had made

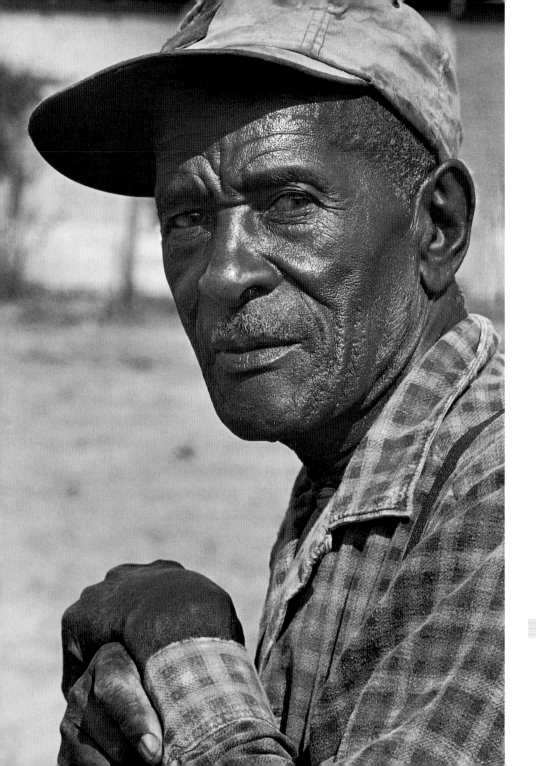

*M*Y GREAT-UNCLE MARCH
FORTH MCGOWAN IN HIS
SEVENTIES

the same mistake. When I went close to Uncle Forth, I felt something hit me in the groin. It was a fast movement, much like the strike of a snake. I looked up with an expression of pain and saw something that scared even that pain away. There was Uncle Forth, draped over the edge of the porch, admiring his fisted hand; pushing out from between his first two fingers was a bit of brown flesh. Uncle Forth was looking this over, examining it carefully. "I got it," he said at last. "You won't be needing this anymore."

Had he really snatched my "horse" when he hit my groin? Could he really have my penis in his hand? My shock, my disbelief, my fear, my regret, all merged into one emotion: I was petrified. I couldn't move. Just as I was about to collapse under the weight of my tremendous loss, he opened his hand and I saw that nothing was there. I had been looking at his thumb.

Sensing my relief, Uncle Forth began to laugh. "I told you, if you don't zip up your pants after you use the bathroom, you could lose your horse. Be more careful or I'll keep it next time." From that moment on, I made sure there was no next time.

Uncle Forth was brother to my father's mother, Granny Faith. Daddy Jordan and Mama Annis McGowan had fourteen children, of which Uncle Forth was the eighth. The seventh child was my uncle John—Gabriel Guster Preston Brown Elijah John McGowan. As luck would have it, the next child was also a boy, catching Daddy Jordan totally unprepared. After a couple of frustrating weeks, the midwife, wanting to complete the birth certificate, insisted that the perplexed parents come up with a name. In the end they named the new baby

OVERLEAF: THE MASONIC HONOR GUARD AT UNCLE FORTH'S FUNERAL

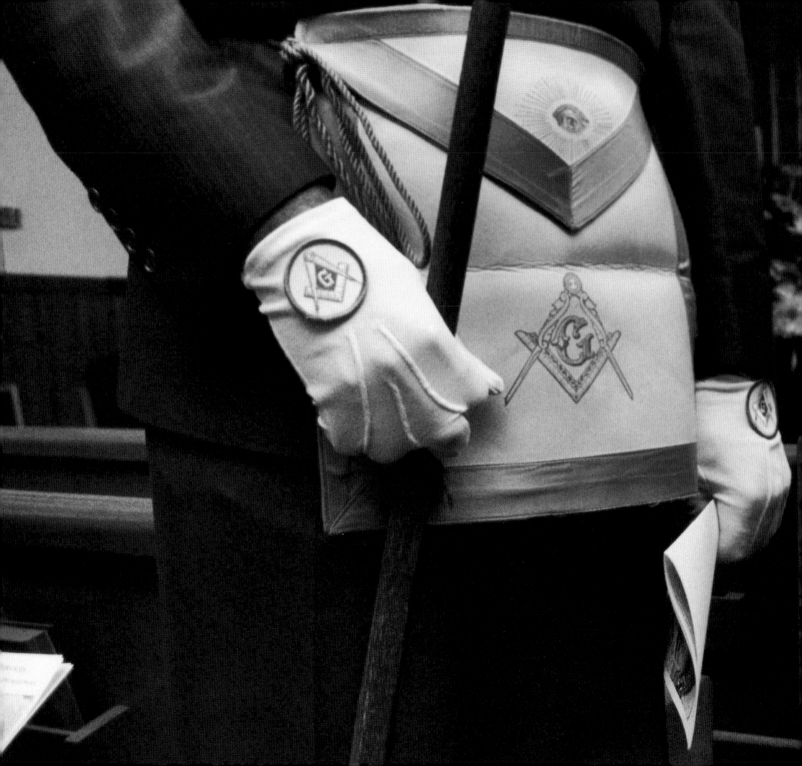

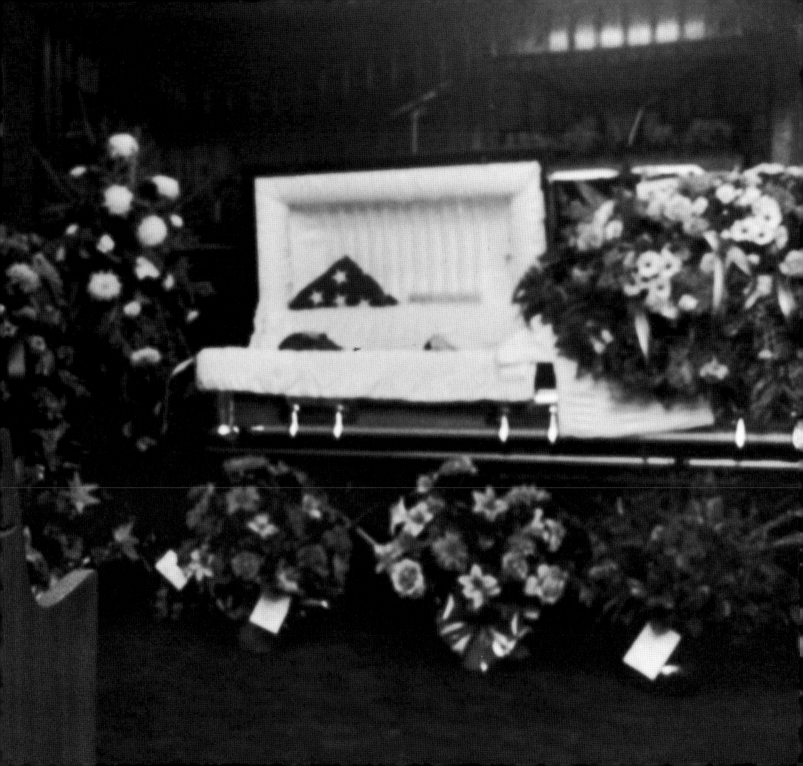

after the day he was born: March Fourth McGowan. In time the spelling changed to Forth, giving an entirely different meaning to his name.

When I became a teenager, I joined Uncle Forth and my daddy in one of the rituals of our rural county. We call it night fishing. After supper Daddy drove us to one of the creeks off the Pea River. There, using flashlights, we unwrapped a mass of short lines, each with a hook and sinker, from a length of wooden board. We cut small branches to make fishing poles. Attaching the lines to the poles, we baited the hooks with crickets and earthworms, dropped them into the creek, and jammed the end of each pole securely into the bank. We set the poles about fifteen or twenty feet apart along about five hundred feet of creek bank. Once all the poles were in place, we lit a campfire and sat around it, snacking on Honey Buns and MoonPies washed down with strong coffee. It was time to relax and enjoy each other's company while we waited for the fish to take the bait and get hooked. Rarely did we go home without more than enough brims, catfish, and an occasional eel to feed both our households for several days.

On one of these excursions, we came upon a log straddling the creek. Uncle Forth decreed it an opportunity to fish both banks of the creek. Before he started across the log, he and my daddy asked if I would be comfortable balancing on the log. Long ago I had asked Uncle Forth how to walk just such a log, and for years I had been practicing on the railroad rails. Uncle Forth had instructed me not to look at my feet and not to think about where I could fall; he told me to focus on a spot on the ground at least three feet ahead and extend my arms sideways for balance. My feet, he assured me, would follow my eyes. Walking the

felled tree that night turned out to be a breeze for me. I had no fear that I might fall as I marched proudly across the creek behind Uncle Forth and in front of my daddy.

Whenever I come across scuppernongs—Muscadine grapes—I am immediately transported back to Uncle Forth's yard. I spent many a summer gorging myself on the taut, plump, nearly bursting yellowish green grapes that grew so prolifically on his vines. It was hard to stop eating them. What kept me in line, though, was the huge, buzzing wasps I had to contend with. They too were addicted to the incredibly sugary juice. Still today I fight the wasps, only now at my favorite greengrocer's in Brooklyn's Bedford-Stuyvesant neighborhood, one of a select minority that stocks this southern delicacy.

In fall I often joined Uncle Forth at our town's syrup mill. County farmers brought their sugarcane harvests to the mill. Uncle Forth was the chief cook, who oversaw boiling down the juice in large vats. The resulting thickened syrup was decanted into gallon tins and returned to the farmers, minus a portion paid to the cadre of cooks. The whole process required tremendous amounts of firewood to keep the contents of the many vats boiling. That was how I helped out. In exchange for collecting dry wood and running errands, I often was "paid" with a quart of the delicious, satisfying raw juice.

One of the greatest gifts Uncle Forth gave me was his acceptance. As I matured, I wanted to spend more and more time with my favorite uncle, and he would sit with me under a tree for hours and talk. Most of the time I was content to observe and listen; when I had a question, I always felt comfortable asking it.

Years later, after I had been away from home for decades, I often thought of Uncle Forth and sometimes picked up the phone to hear his voice. When my mother died and I came home to bury her, I went straight to see Uncle Forth, then 103 years old. I was looking for emotional affirmation for my pain, and his response stunned me. "We all have gotta go that way someday" was what he told me. In retrospect, I believe his response was heartfelt and most unique. Everyone else validated my pain and offered sincere condolences; it felt good receiving them, each one like the offer of a branch of a tree to rest on. But today I can't match words with faces. Only Uncle Forth's face elicits words in my memory, words that no one else dared to say: "We all have gotta go that way someday."

Early on I observed that Uncle Forth's kin lived to be old and did it with grace. When I was still a teenager and Uncle Forth was in his seventies, I asked him the key to long life. "Take everything in moderation and don't abuse yourself," he told me then. Later, when Uncle Forth reached 105 and I came back to help move him into a nursing home, I asked if he remembered our conversation so many years before. "Sure I do," he said. "And today? What's the secret to long life?" I persisted. "A pork chop and a shot of Jack Daniel's a day," he said this time, with no hint of sarcasm.

I have to admit I was reluctant to accept his response. In the first place, our county was dry, and as far as I know always had been. I did learn, though, that in the nursing home Uncle Forth managed his strong drink with Nyquil. Every evening his great-nephew Lenwood Herron visited, and it became his responsibility to bring the Nyquil. And who

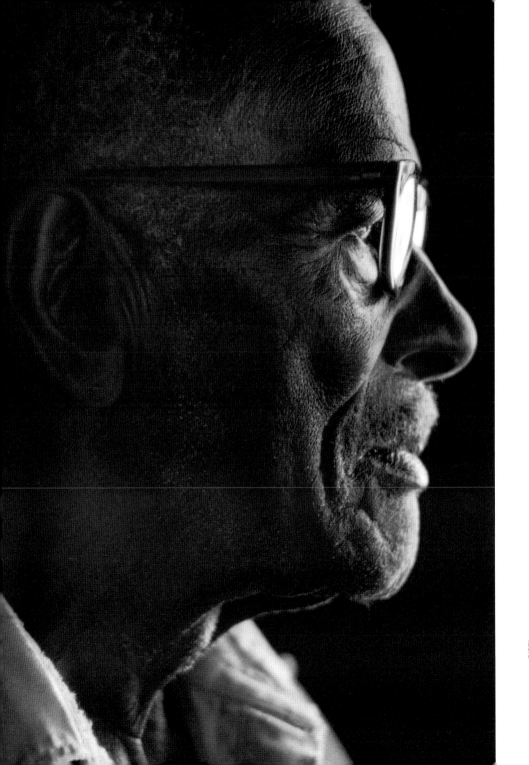

UNCLE FORTH AT NINETY
YEARS OLD

knows—before he moved from his home, Uncle Forth could well have eaten a pork chop a day. Yet I'm perplexed. As I near my sixties, I am just beginning to learn how to embrace moderation, and I finally know enough to steer clear of physical, emotional, and chemical abuse. As a southerner, I grew up on pork and beef, but since 1983 I have eaten neither, trying to stay away from red meat, which medical reports tell us can raise blood pressure. But perhaps after eighty we need a jolt to our systems; if so, then that pork chop and Jack Daniel's might just be the thing.

Uncle Forth passed in 1998, just three days short of his 108th birthday. When I was told of his death, I felt the loss, but I decided it was the opportune time to marry the woman whose loving heart produces smiles that inspire happiness deep within me. Even though it's certainly untraditional, I wanted our marriage ceremony to take place at his grave site following the funeral. His spirit would make the site sacred and the most fitting place for our union. Betsy and I had been dating for fifteen years then and we'd already decided to marry, just not where and when.

When the minister announced at Uncle Forth's funeral in the Poplar Springs Baptist Church that there would be a wedding at the cemetery, people were shocked. The aptness of the expression "You could hear a pin drop" became clear to me that afternoon. Later I was told that a few extra people, made curious by the announcement, came to observe the final rites at the cemetery—in spite of pouring rain, which by the following morning had caused the river to reach flood level.

At Hardshell Cemetery, the Poplar Springs minister gave the last rites to Uncle Forth's body. Before his casket was lowered into the grave, another minister took over. The Reverend Virgil Coleman, a man known to me since adolescence, is a minister, funeral director, and my former high school principal. He asked Betsy and me, her daughter, Elizabeth, and my daughter, Nataki, to stand at the head of the casket. My son, Damani, made pictures, and my father sat and wept. I came to Uncle Forth's homecoming ceremony a single man accompanied by the woman who brings so much happiness to my life. I wanted Uncle Forth's spirit to share my happiness and for our union to be blessed by his spirit. So in the company of a hundred citizens, twenty feet from the graves of my mother and grandfather, we took our vows. At the conclusion of our ceremony, the casket was lowered and we all made our way through the thick, gooey mud and unrelenting rain to our waiting cars. Being there beside Uncle Forth's grave, wrapped up in the memory of his life, made our commitment so much more special.

Uncle Forth's words—"We have all gotta go that way someday"—made it easier for me to let him go. In the minds of church people, the cycle of living takes on epic proportions; birth is sunrise, death is sunset, and funerals are homecomings. In the company of those present, my heart had no choice but to wave goodbye to my favorite uncle. And who knows—perhaps he's reserved a spot near him just for me.

Tucker

From time to time when I was growing up, I heard the name Tucker. I didn't know Tucker West or much about him, except that one night before I was born he left New Brockton mysteriously. Even though we hadn't met, I was sure I would like him. It was something about the loving way his relatives spoke his name, and perhaps the secrecy that shrouded his departure.

And I do like him. We met for the first time at the funeral of his uncle and my great-uncle, March Forth McGowan. Tucker's parents were my great-uncle Ernest and great-aunt Doll, who was Uncle Forth's sister, which makes Tucker my cousin. Tucker's mother had passed almost three decades earlier, but another sister, Val Brock, was still living. Back home for Uncle Forth's funeral, I stopped by to visit with Great-aunt Val. I expected to find one of my favorite relatives, Elma, her daughter, but Elma's brother Cecil was also there, and so was Tucker.

COUSIN TUCKER IN NEW BROCKTON FOR UNCLE FORTH'S FUNERAL

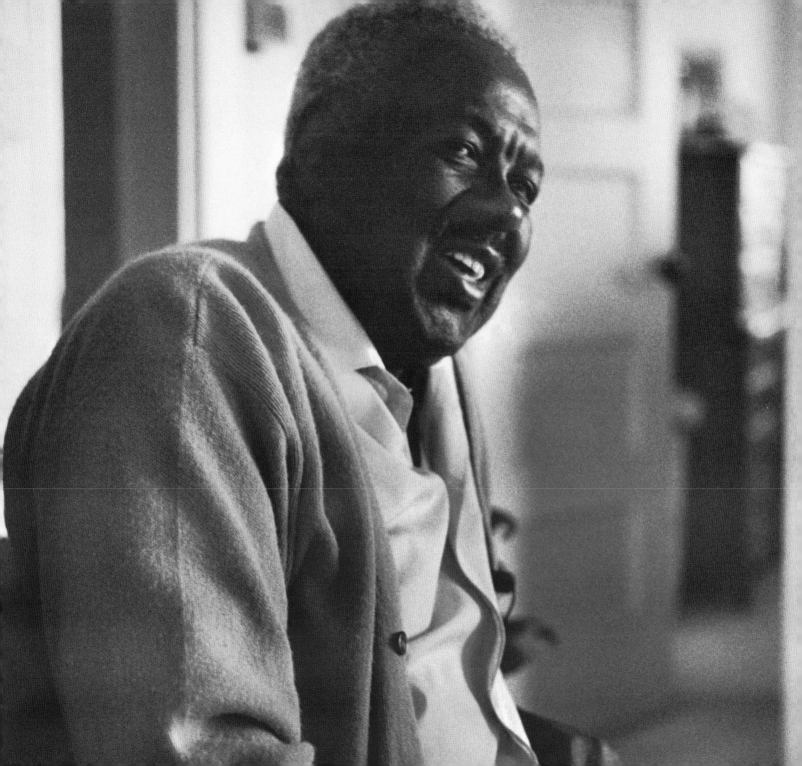

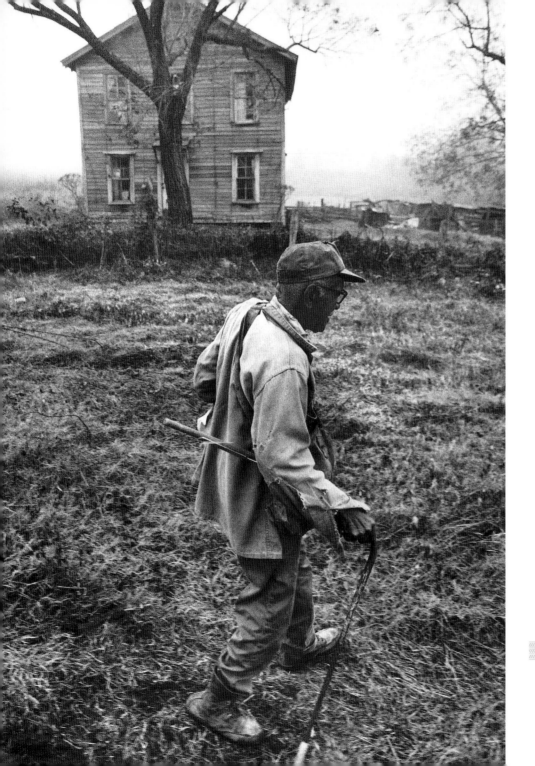

*U*NCLE *F*ORTH PASSING THE
MASONIC LODGE

I was thrilled to finally meet him. In time we wore down everyone and it was just Tucker and me. Our conversation drifted to stories of Uncle Forth, a man who not only profoundly inspired my life but, I discovered that afternoon, even more dramatically affected Tucker's. Uncle Forth didn't have children, but he looked out for his nieces and nephews as if we were his own. I think we all had turns night fishing with Uncle Forth. On one of those trips, Tucker started out after Uncle Forth across a log over Malt-Malt Creek. What looked easy when his uncle did it was a disaster for young Tucker; he fell in. "By jinko," he remembers Uncle Forth yelling; it was his favorite expression of exasperation. "I can't turn my back on you for a minute." He pulled off Tucker's wet clothes and lit a fire to dry them. Protected in Uncle Forth's shirt, which went all the way to his ankles, Tucker watched his uncle slap away hordes of mosquitoes from his own bare chest, arms, and back.

Another time Tucker had a different kind of experience, but he says, "Everything Uncle Forth did was out of love." Tucker was older then, around sixteen. Uncle Forth took him along to a job in Mobile, Alabama, where he was working on the construction of a new runway for the military airport. "He was teaching me to be a cement finisher," Tucker told me. One night, with a little money in his pocket, Tucker went out and got drunk. When Uncle Forth saw him, he shouted, "By jinko, your mama will kill me if something happens to you." He was so angry he struck Tucker with a two-by-four and dragged him out to Dog's River and dunked him in the cold water to sober him up. "I kept telling Uncle Forth he was going to kill me," Tucker told me, laughing,

"and he just kept dunking me and saying my mama was gonna kill him. But he nearly did kill me."

Whatever Uncle Forth might have done that night in Mobile, there is no question that he saved Tucker's life five years later. Tucker was still a teenager when he went off to fight in World War II. He came home a young veteran, barely twenty-one years old. Back then returning veterans could carry weapons, and Tucker by his own admission loved guns and kept his close. Trouble started one day when Tucker was playing his piccolo on his front porch and New Brockton's policeman pulled up out front. Tucker's dog took off like a streak, racing toward the car and barking loudly. Without a word, the policeman drew his gun and fired it twice at the dog. Tucker was furious. "You mess with me again and I won't miss," he told the policeman amid a string of curses.

Threatening a police officer is bad enough, but what Tucker really did was break the unspoken rules of the Deep South in the 1940s. The policeman was white, and no matter how much Tucker may have wanted to stand up to him, his behavior put his life at risk. But that was Tucker. He was crazy, stubborn, and fearless.

A few weeks later, Tucker and some of his buddies were sitting on a log drinking home brew outside the local dance hall in our dry county. The police car screeched to a stop and the men stashed their bottle behind the log. Everyone jumped up and stepped back—except Tucker. The policeman, ranting and raving, started firing questions at him. It seems the man was about to be dismissed from his job. Someone had told the town council that he was turning a blind eye to Boss Sistrunk,

our local moonshine dealer, and he was desperate to uncover the informer.

Getting nowhere with his inquiry, the policeman called Tucker "uppity" and ordered him into his car. But Tucker had had enough. He knew then what my daddy told me much later. A year before, this same police officer had killed a young black boy outside a candy store in Coppinsville, a black hamlet on the outskirts of nearby Enterprise. Apparently unhappy with the boy's attitude, he shot the unarmed child at point-blank range and left him to die on the ground. My daddy came upon the scene right after the shots were fired. There was never any kind of inquiry, and the policeman was never charged. He transferred, however, to a new town—ours. Now Tucker feared for his life.

As the policeman turned to open the car door, Tucker pulled his gun and fired. The bullet, he thinks, grazed the man's head, because he stumbled and fell to the ground. But he bounded up, jumped into the car, and sped off toward town. Tucker's buddies scattered; everybody knew the policeman would be back. It didn't take long before he assembled a mob and began searching for Tucker.

Tucker simply went home. That turned out to be a stroke of luck, or genius. Who in his right mind goes home when a mob is hunting him?

Word spread quickly among blacks and whites. When Tucker's father heard the news, he demanded that his son leave town, but Tucker wouldn't budge. And so sometime after midnight, Mr. West went out to consult with Herbert Jones, his boss at a dry goods warehouse—the only white-owned business in our village to hire a black employee. He

OVERLEAF: *Swamplands near the Pea River outside New Brockton*

61

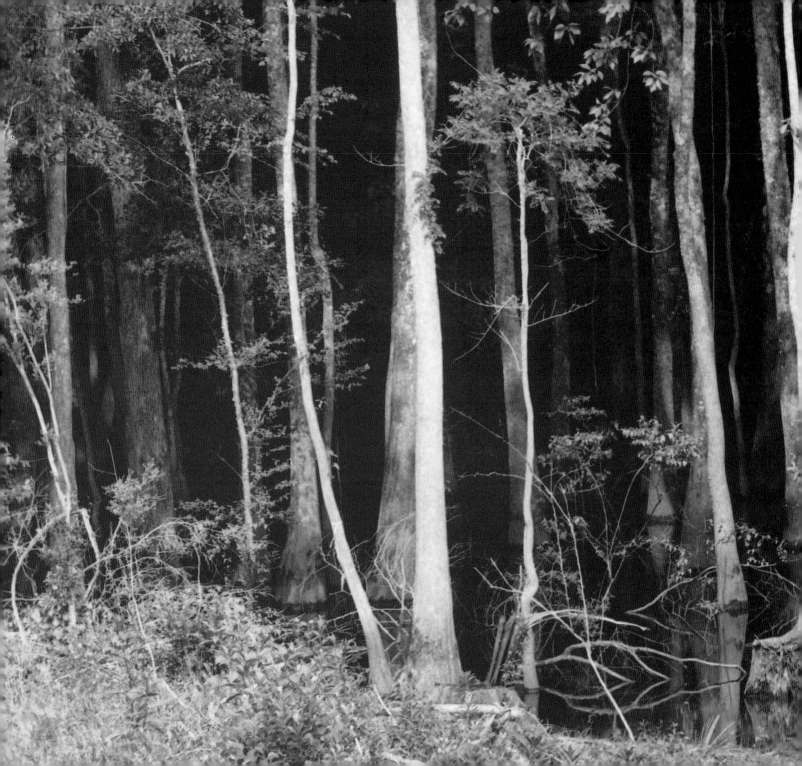

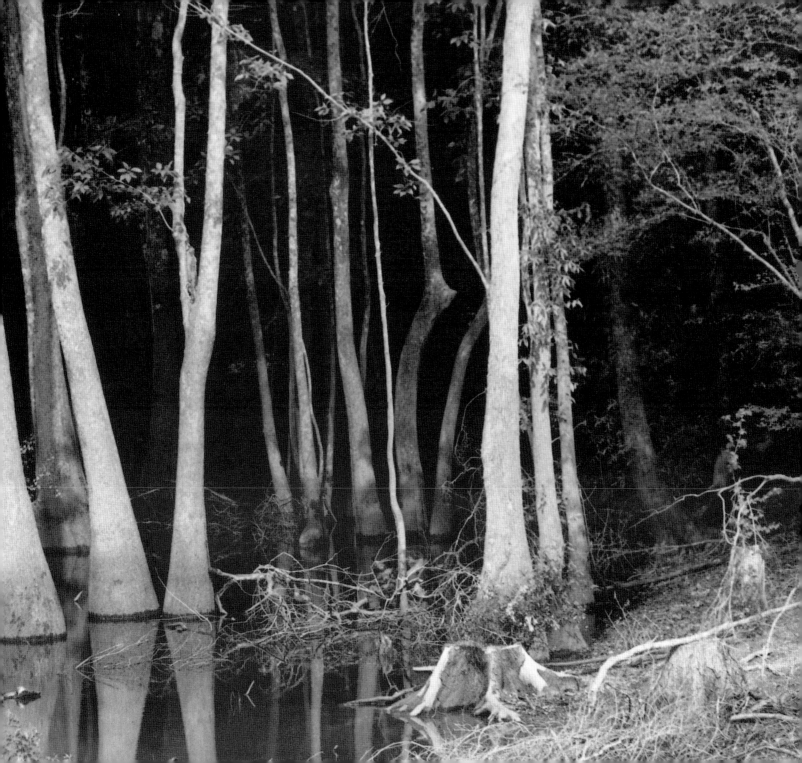

and Herbert Jones had been friends since childhood. Herbert and his wife, Lucille, had a reputation among blacks for being fair. All three agreed—Tucker had to flee, and fast. Tucker had shot at a white man, and in 1940s Alabama that added up to a lynching.

Ernest West and Herbert Jones devised the plan that saved Tucker's life, but Uncle Forth was pivotal to its success. When he got word, Uncle Forth shouldered his double-barreled shotgun, pocketed a bag of shells, and rushed to his baby sister Doll's home. There he found Tucker lying across his bed. "Boy," he shouted, "get up! We got to go." Somehow this time Tucker recognized the urgency of his situation. He and Uncle Forth left out the back door, but not before he collected his rifle and handgun. Together Tucker and Uncle Forth tramped five miles through the woods to a dirt road close to Enterprise. If they had been ambushed, Tucker told me, he planned to go down fighting. They might get him, but he would have gotten some of them on the way. And no doubt Uncle Forth would have done the same.

Herbert Jones called Enterprise's black undertaker, Ray Sconiers, who agreed to rendezvous with Tucker and Uncle Forth when they came out of the woods. Mr. Sconiers was instructed to drive off Highway 84 onto the dirt road down to Moates Quarters in his hearse with an empty casket.

Then Mr. Jones alerted some sympathetic white Masons. The leader of the local black Masons, Frank McGhee, took over for Tucker's father, who by that time was being watched, and mobilized all the Masons he could contact—a difficult task in a time when few phones existed in the black community. The group of supportive white Masons

*T*HE MAIN INTERSECTION OF DOWNTOWN NEW BROCKTON IN 1999

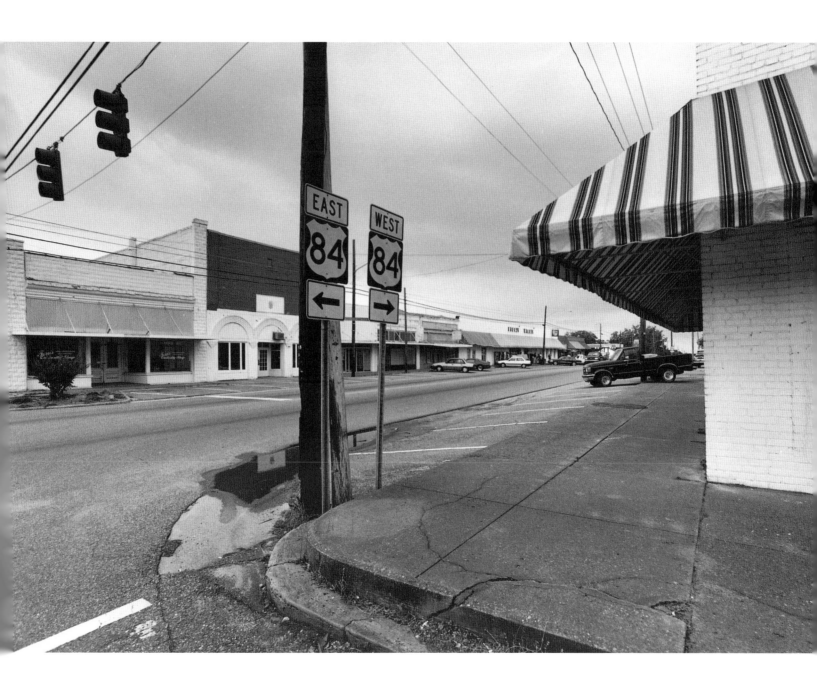

drove to a spot just short of the rendezvous point, where the dirt road spun off the highway. They waited in case the mob came that way; they were there to talk the policeman and his posse out of their mission, or at least delay them. The black Masons rushed to where the hearse waited for Uncle Forth and Tucker—extra hands to fight if necessary.

Just before dawn, Tucker and Uncle Forth, both Masons themselves, emerged from the shelter of the woods where the armed black Masons waited near the hearse and the casket. Tucker climbed into the empty casket. He had to give up his rifle, but he tucked his handgun in with him. Mr. Sconiers drove back down the dirt road to Highway 84. He passed the white Masons at the intersection and then turned east. The light was just beginning to rise as he drove his hearse with its live passenger across Alabama all the way to Thomasville, Georgia. There Mr. Sconiers went to the house of a local Mason, where Tucker was able to get out of the hearse unseen. A relative of Tucker's came by the house with ticket money. That evening Tucker boarded a train going north to New York City, where his aunt Mary Alice lived. It was September 9, 1946.

Tucker never set foot in New Brockton again until 1962—the year his mother passed. A few years earlier, when his father became ill, Tucker visited him in nearby Dothan, where he ran a café and nightclub. It was not yet safe for Tucker in New Brockton.

When I was growing up, Tucker's story was still too fresh for comfort; no one wanted to give details for fear of retribution. Even today Tucker isn't comfortable talking about it. He still struggles with what happened that night and what his actions set in motion.

He is proud, he says—proud of himself, his family, and his friends. It made him feel good when he heard that Frank McGhee, the leader of our black Masons, was known to say, "What we need are more Tuckers." "But I can't help but feel sad and even guilty," Tucker says, "knowing that some folks felt my actions made it much harder for the black people who stayed in New Brockton."

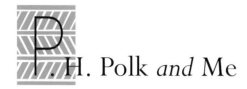H. Polk *and* Me

CHAPTER TWELVE

One fall afternoon in 1967, I was in the downstairs office of P. H. Polk's
studio on Washington Avenue in Tuskegee, waiting for him to finish
drying some prints. As the advertising manager for our Tuskegee
University student newspaper, I had arrived in an impatient mood, ready
to hurry the photographer along. My editors were on deadline and the
prints should have been finished long before. Since I had initiated using
photographs in advertisements, I felt responsible. To pass the time and
to distract myself from my mounting impatience, I began to look at
Mr. Polk's photographs scattered about the room.

There were many prints, mostly in disarray—some on the wall,
some under glass on the counter, some in frames. They were all striking
pictures of people. Here were portraits recording the lives of people at
Tuskegee University—photos of professors, their wives, their children,
their grandchildren. And some were of the social groups and activities
of administrators and students at the university.

P. H. POLK IN HIS STUDIO
IN TUSKEGEE

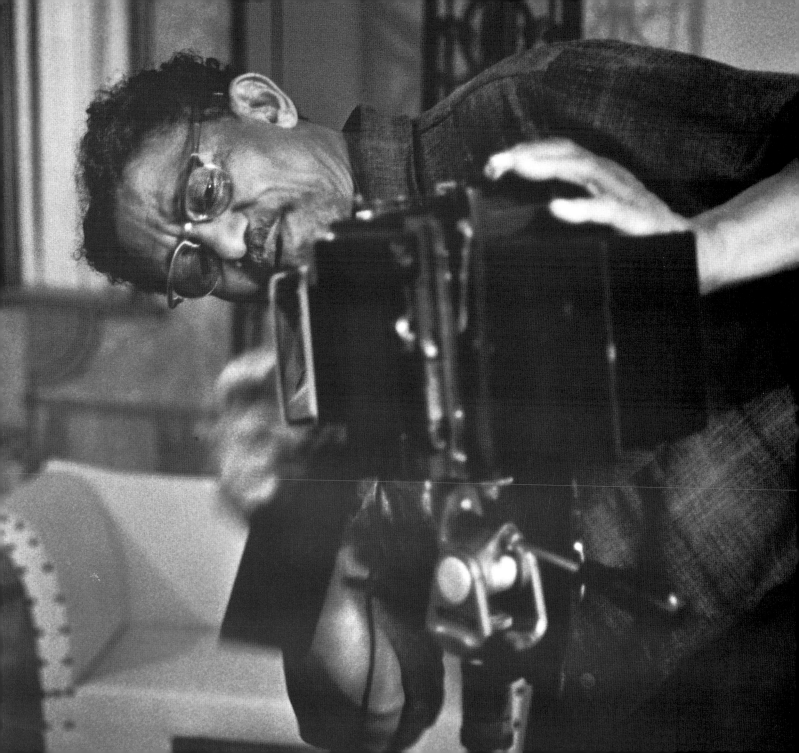

A door opened, and from behind the studio curtains the figure of Mr. Polk dashed out, holding a wet print. He showed me the image, and I felt reassured that at least one print was almost ready, even though he still had more film to process. He disappeared back through the curtains, but before the black fabric fell into place, I caught a glimpse of some photographs on the inner wall. Five of these grabbed my imagination the moment I laid eyes on them. After the door closed again, I ducked through the curtains to have a better look.

Hanging crooked on the wall were pictures of older men and women, standing in all the pride of themselves. Although made in the 1930s, the pictures entranced me in 1967, and they hold the same power when I see them today. The people in these photographs differed from the ones in Mr. Polk's other works. These subjects, seemingly rural religious people, were so familiar to me. As a youngster, I had seen people with the same dignity and character in my church and among farmers.

The door opened again, and out popped Mr. Polk. He told me it would take him longer to finish, and he invited me into his lab to watch and wait. I agreed, eager to ask him about the pictures that had touched me. He told me that he had made them some thirty-five years before, far out in the country. When someone caught his eye, he simply stopped and invited that person to be photographed.

Excitement welled up inside me as I imagined making such a picture of my great-aunt Shugg Lampley. Aunt Shugg was a midwife, bow-legged and loving, who made a to-die-for blackberry pie. I envisioned portraits also of Uncle Forth and of his brother, Uncle John, as well as of Uncle Bougg McGowan walking behind his plowing mule.

THREE FARMERS ON THE PORCH OF A COUNTRY STORE

My inquisitiveness elicited more descriptive answers concerning the pictures on the wall, as well as some others that Mr. Polk uncovered and blew dust off of. I sat there reliving an era that had passed before me so quickly when I was still a child. The era was gone, but thanks to photography, these people seemed to live on. I was staring into their world and loving every minute of it. For me, these photographs held power. I felt drawn into the lives of the subjects. I was impressed by their faces and grateful that Mr. Polk had had the skill to record them for posterity. Although they may have been dead, their images were there in the room with me. I felt satisfied. I was enriched.

I needed a camera. Some days later, having met the deadline and fulfilled my obligations as advertising manager for *The Campus Digest*, I returned to Mr. Polk's studio, where I found him just waking up from his afternoon nap. He always worked late into the night in his darkroom.

My confrontation with his pictures from the 1930s had unleashed another kind of yearning: I wanted to become a photographer. He made it look so easy. All he did was carry a camera slung around his neck. He put it up to his eye, aimed, and pressed a button. Several times I had noticed during a session in his studio that he might try different angles before putting away the camera and processing the film.

I looked into his face and said, "Mr. Polk, would you teach me how to use your camera? I want to learn enough to be able to go to my home and make photographs of a few people there that I love very much."

Mr. Polk leaned toward me, giving me careful study. I began to feel anxious.

"Let me understand this," he said. "You want me to lend you my

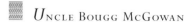 UNCLE BOUGG McGOWAN

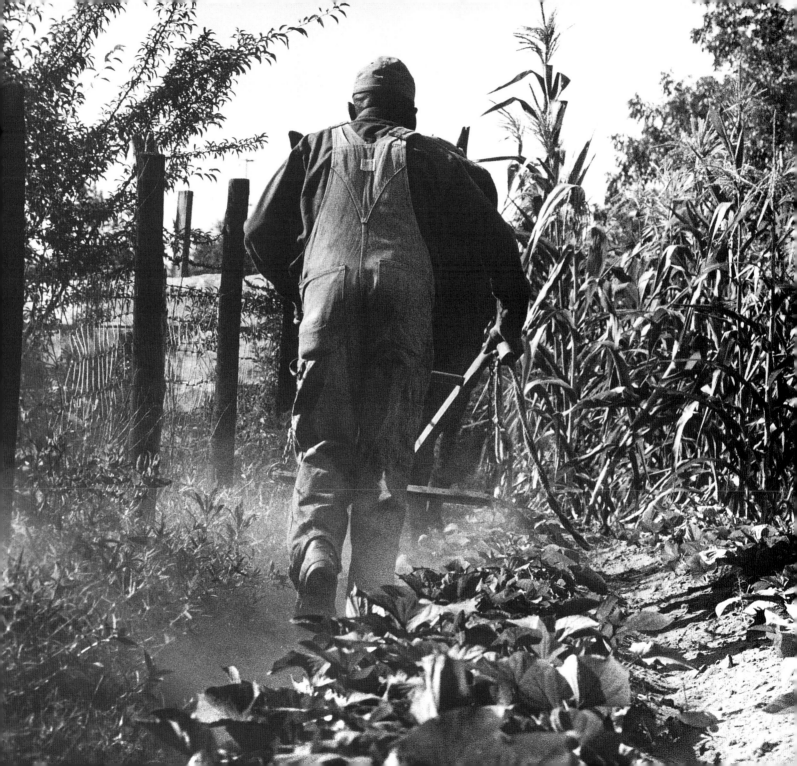

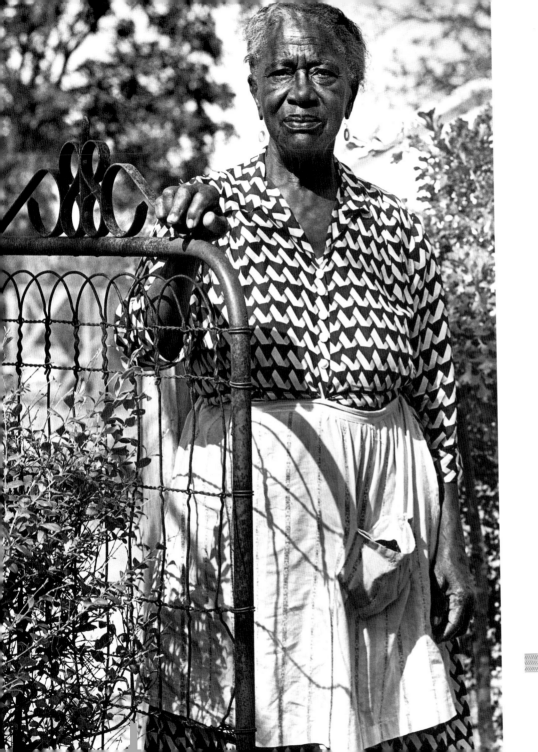

Aunt Shugg Lampley

camera, the one that I have to make a living with, to teach you how to make a picture?"

"Mr. Polk, yes sir!" I answered, as enthusiastically as I could.

There was an awkward, long moment before he continued. "Well then, I'll tell you what I'm gonna do, I'm going to be just as big a fool as you. If you're fool enough to ask that of me, then I'm gonna be fool enough to help you. I'm going to lend you my camera."

Right then and there he gave me a lesson on how to use his camera, and I agreed to return it in a few hours. An hour later I was back with an exposed roll still in his Pentax. My film stuck at the end of the roll, because I didn't know how to rewind it, and unwilling to risk ruining it, I had just left it in the camera.

He removed the film, and we both went into the darkroom so he could process it. It was a disaster! Out of a roll of twenty exposures, only two came out. I couldn't understand what I had done wrong.

Then Mr. Polk began to correct me. I had failed to grasp how much light was needed to expose film. Even though his Pentax didn't have a light meter, he made reading light seem effortless. It was this skill that he concentrated on—giving me lessons on the necessary f-stops for shooting in the shade, in the sun, and indoors.

After I had borrowed the camera a second time, I sensed that Mr. Polk was reluctant to let his only 35mm camera out of his sight. I still visited him and asked him many questions, absorbing his lessons, but I never asked for the camera again. That summer I bought my own (with a built-in light meter), which I proudly showed off to him when I returned to school in the fall.

After a messy and unsuccessful bout with darkroom chemicals in my apartment bathroom, I asked Mr. Polk if I could pay him to process my film for me. I knew this would give me the opportunity to learn more from him about shooting and darkroom technique.

One day I stopped by to pick up my prints and began talking what Mr. Polk called "craft nonsense." I had saved some money and had been reading photo magazines. I thought I was ready for a new, more modern system. I told Mr. Polk I was planning to travel to a camera store in Auburn, some thirty miles away, to purchase it. Mr. Polk stepped back and quietly told me, "There is no camera that can make a picture. No lens, no lights can make a picture. Forget about different cameras and accessories—just use what you've got. Only your eyes can make a picture."

I found Mr. Polk an easy man to love. He possessed great dignity and such uncluttered openness. He and his subjects shared the same human qualities—they had the same air of self-knowledge. In some way he entered into the hearts of the people he photographed.

Words came easily to Mr. Polk. He knew how to make his photographic subjects feel comfortable. If a man was stiff, invariably Mr. Polk would say, "Imagine you are in the jungle. You have a rifle and one bullet. A bull and a lion are charging at you. Which one would you shoot?" After some hesitation, being curious about what the question had to do with having his picture made, the sitter would almost always answer, "The bull." "No," Mr. Polk would say. "You should shoot the lion, because you can always shoot the bull." The tension would break, and with it the sitter's anxiety. Having set up the moment, Mr. Polk was ready to click his shutter.

A WINDOW IN AUNT
SHUGG'S HOUSE

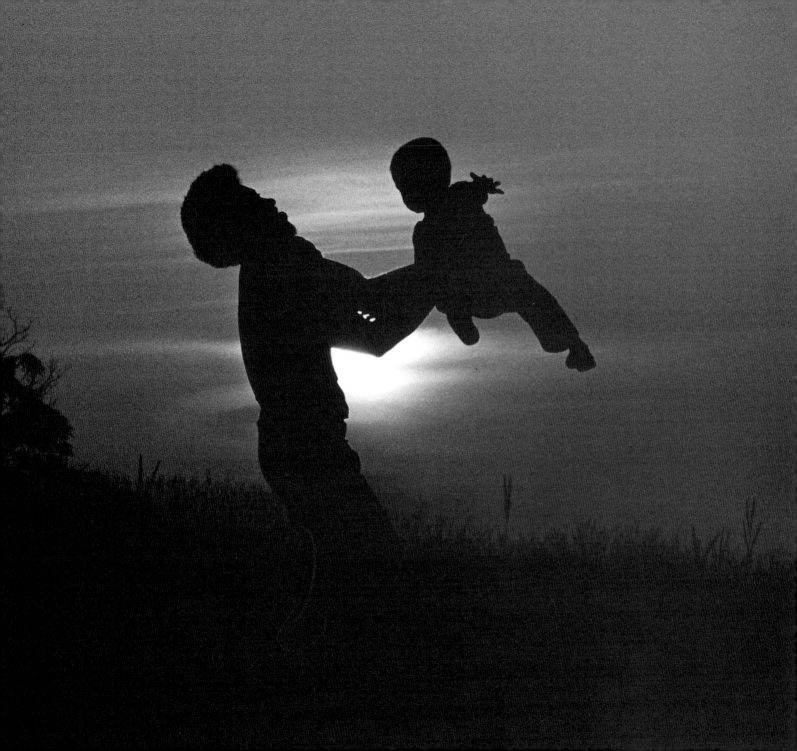

Another of his favorite lines was "What part of Mississippi are you from?" With the reputation Mississippi had for extreme repressiveness toward African Americans, nobody wanted to be from that state. In the process of vehemently setting Mr. Polk straight, his subject always forgot about the camera. After Mr. Polk made the picture, he would say, "Well, I could have sworn you were from Mississippi, but I see now you are from somewhere else."

For me, Mr. Polk's photographs epitomize the rural South of my youth. With his camera, he was able to bring out the heroic qualities of his subjects, capturing their true essence. He simply liked people and let them know it.

An Alabama sunset

What Is Your Message?

I purchased my first camera in 1968, the summer before my junior year at Tuskegee, and spent that whole school year shooting and picking up pointers from P. H. Polk. Once final exams were over in June, I headed to Manhattan and the nearest newsstand, where I copied the names of photo editors from the mastheads of *Time*, *Newsweek*, *Life*, and *Look*—all the magazines I could find that relied heavily on photographs. It was the height of the civil rights movement, and like thousands of other students nationwide, I protested against racist Jim Crow laws. But my fellow students and I looked like vicious criminals in images run by the Alabama press—strikingly different from the photographs I was making at rallies.

I came to New York to make my kind of photographs. I knew the media weren't going to stop printing negative images of people of color, but I hoped to contribute something positive to the visual diet. The only chance I had to do that was to learn to make pictures as compelling as those published by the best photographers.

A CIVIL RIGHTS DEMONSTRATION BY STUDENTS AT TUSKEGEE UNIVERSITY

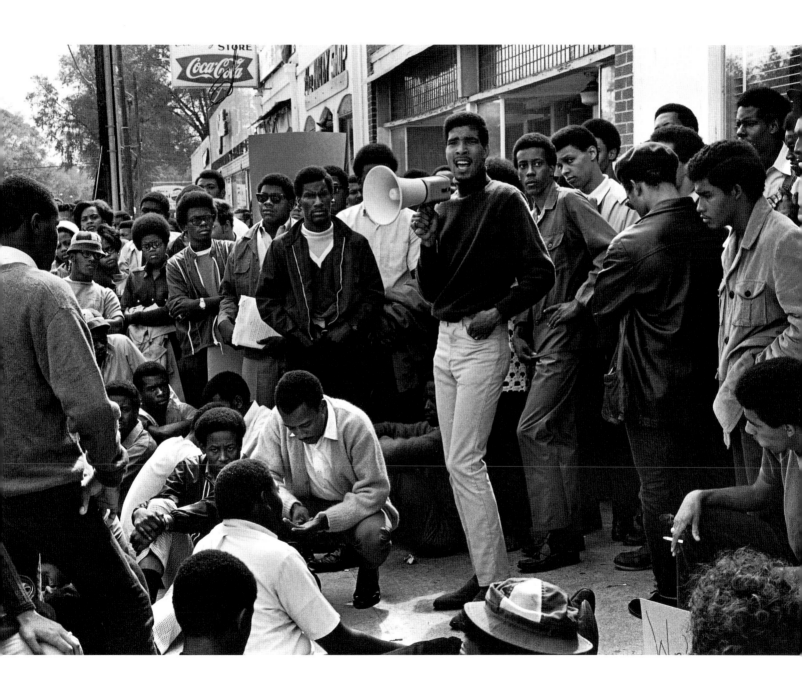

With a portfolio of my prints in hand, I telephoned photo editors, telling them I was not looking for a job; I wanted criticism. Tuskegee offered no photography courses, and I was desperate to learn more. Fate smiled on me the day I met with *Look*'s picture editor, Sam Young. In the middle of our appointment, an energetic, impeccably dressed man with a smooth bald head burst in. He was Arthur Rothstein, *Look*'s director of photography.

Mr. Rothstein invited me to stop by his office, and that afternoon I showed him the twenty images I considered my best work. Selecting one and placing four sheets of white paper on the four sides of the photograph, Mr. Rothstein maneuvered the papers until he had shrunk my image. It all happened in a second. "Here is the picture," he told me. "All the other elements are in the way—they compromise the real image." He was right. It was obvious. It was my initiation to cropping— the first time I heard the word.

In the next hour, Mr. Rothstein introduced me to a host of visual concepts: design, balance, composition, lighting, positioning. And then he asked me, "What is your message? What are you trying to say?" At first I was reluctant to answer, fearing I would sound too idealistic, but I knew it would be a waste of his time and mine not to be forthcoming.

"Our media show no positive images of decent black people," I blurted out, "men and women who work hard, go to church, have respectful and loving relationships. We need images of black people that reflect the fullness of our lives."

Arthur Rothstein in his office at *Look* magazine in 1970

82

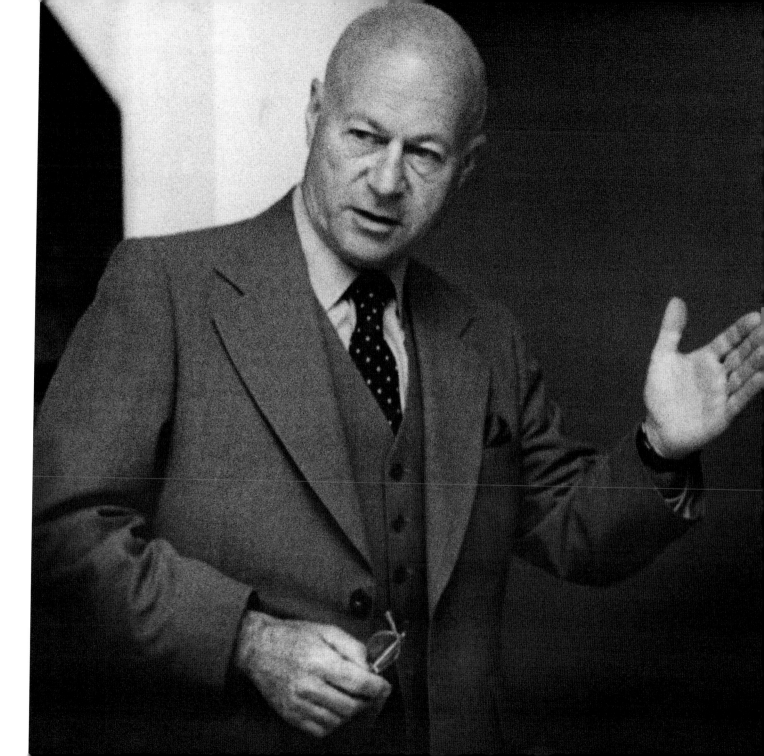

He looked at me for a moment, perhaps gauging the strength of my commitment. "That's a tall order," he said.

I nodded and pushed ahead. "Could I learn from you this summer? I need help training my eye." I don't know what it was that made him agree to work with me, but he did.

Day after day that summer, I returned to the *Look* offices. Mr. Rothstein, dressed in his trademark three-piece suits, always found time to be with me; he loved talking photography and would punch the air with his index finger to differentiate his many points. One of the very first things he told me to do was put my camera down. Use your thumb and forefinger on both hands to frame images, he directed; practice until you learn to compose your picture right in the camera. "There is no sense spending one one-twenty-fifth of a second to make the picture in the camera," he loved to say, "and then an hour in the darkroom to make it work."

My head was reeling with all this new information, so I asked Mr. Rothstein to give me a practice assignment to see how much I understood. He chose a day in the life of office messengers. Before letting me go, he discussed the importance of previsualization—thinking about picture possibilities—but remaining open to discovery, being sensitive to what might unfold.

Messengers were easy to find, and I tagged along with those willing to talk with me, trying to capture the urgency their jobs demanded. I shot two rolls of film given to me by Mr. Rothstein. What luxury to have real rolls, not the cheaper bulk film you had to wind yourself. The

next morning Mr. Rothstein had contact sheets in less than an hour, and every frame needed improvement. He was kind with his criticism; he picked the strongest image and showed me how I could make it stronger before pointing out why my weakest ones failed.

Finding that I had not yet visited any art museums in New York (or ever), Mr. Rothstein compiled a list of painters and packed me off to the Metropolitan Museum and the Frick Collection. He instructed me to observe subject, composition, balance, and light. "It doesn't matter if you like or dislike a painting," he told me. "It's important to have a reason for feeling the way you do."

At the Museum of Modern Art, he arranged for the photography curator to show me works by the Farm Security Administration photographers Dorothea Lange and Walker Evans. Wanting to see more, I sifted through boxes and came upon works by Gordon Parks, Marion Post Walcott, and finally Arthur Rothstein. In that moment I discovered that my summer teacher was not only my mentor but a famous photographer who knew Tuskegee University very well. As a member of the Farm Security Administration, he had been assigned to document the students and faculty of my college in the early 1940s. Later still, I learned that Arthur Rothstein had helped an amazing number of photographers; they, like me, acknowledge an enormous debt to this generous teacher.

When September came and it was time for me to return to Tuskegee, Mr. Rothstein suggested that we continue our relationship by mail. I couldn't have been happier.

On my last day at *Look*, he handed me sixty rolls of color and black-and-white film. "Shoot them and send them back," he instructed, and he would mail the contact sheets with his comments—which he did for my entire senior year. His influence on me and my career continued until his death, when I, like so many others, lost a cherished friend.

Those Three

Passion defines Cornell Capa. The International Center of Photography—the first private museum dedicated to photography—stands today in testament to his determination to win respect for photography as an art. Arthur Rothstein introduced me to Cornell in the 1970s, when Cornell was working almost single-handedly to gain acceptance for photojournalism in museums and to educate the public to see it as art.

Full of Old World graciousness, Cornell agreed to meet with me at his home and office on lower Fifth Avenue in Manhattan. Every shelf, nook, and cranny was crammed with books on photography; imposing file cabinets held the work of Cornell's brother, the war photographer Robert Capa, whose death had made international news more than a decade earlier. Seated with Cornell around his worktable were his wife, Edie, and his assistant, Anna Winand; here was a team tirelessly committed to changing the world's perception of photography and planting the seeds that would blossom in 1974 as the International

Center of Photography. I am grateful that Cornell invited me to attend the photographic seminars he was giving that summer at New York University, where I was fortunate to see and hear Ansel Adams, Bruce Davidson, Jerry Uelsmann, Yousuf Karsh, and W. Eugene Smith discuss their work and their personal visions.

Cornell, a gifted photographer as well as a visionary, became my friend and mentor. "Terrific!" I can't help but hear that word pronounced with Cornell's distinctive Hungarian accent. His well-tempered advice incorporates the use of photography as a tool for change and for appreciation of the overarching issues that define the human spirit. In the early 1980s, when I was facing a difficult time in my personal life, Cornell challenged me to put order and structure back into my long-term photographic mission. Because of his persistent questioning, I became aware of the evolving trends in my personal work.

Find the Beauty

For nearly two decades, along with several other aspiring artists, I listened raptly to Romare Bearden on Saturday mornings in his studio. This celebrated and politically inspired artist opened his workspace and freely shared his ideas, collectively and individually. "I see that you make finger exercises, but can you make a symphony?" he said to me— words that motivated me to dig deeper into my artistic soul. Where was I going with my work, with my message?

Cornell Capa, the founder of the International Center of Photography

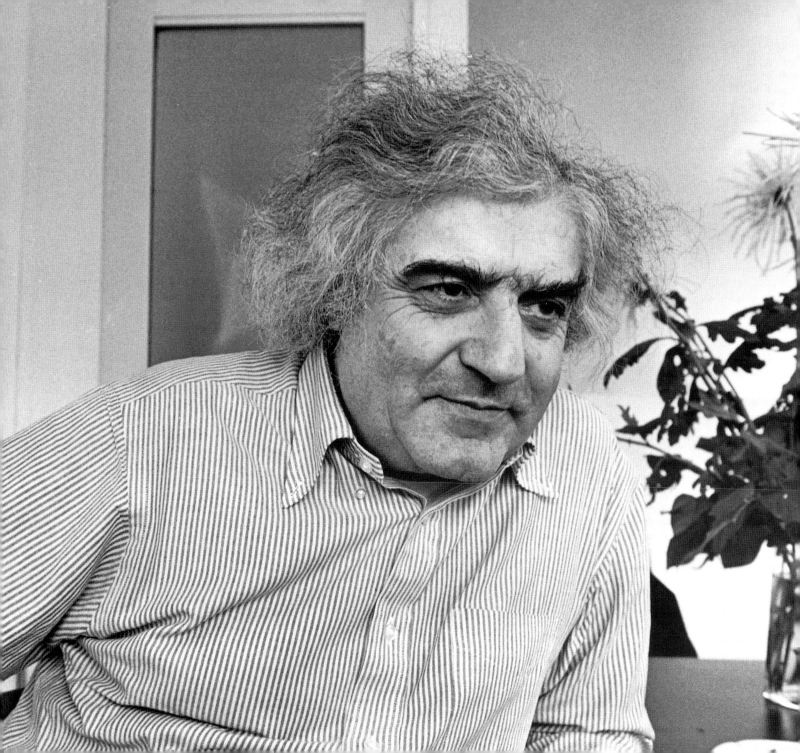

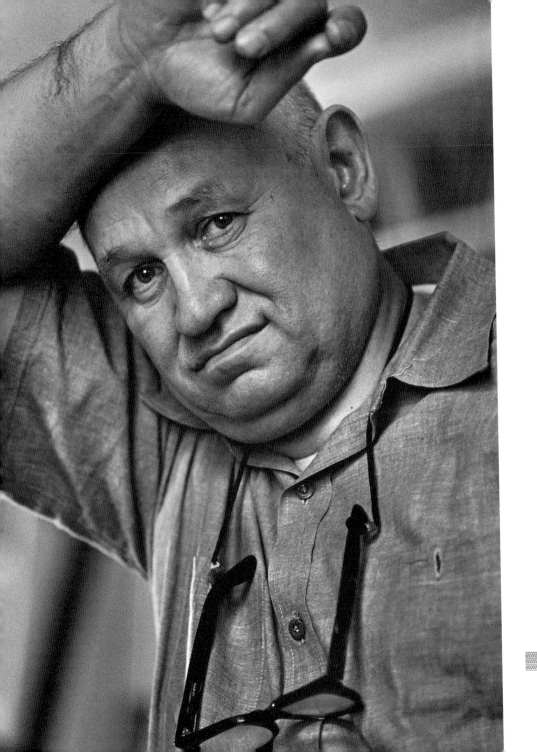

THE PAINTER ROMARE BEARDEN

The moment I set eyes on Romare Bearden's art, I was mesmerized by his treatment of strong colors and his fractionalization of time and space. I happened to be putting together my second photography book, *Drums of Life*, which was about men, and I wanted to include a portrait of him. He agreed. I showed up at his loft on Manhattan's Canal Street and rang the bell. Three flights up, a window opened, and Romare threw down keys. After climbing the three long staircases, I entered his loft and he made tea, which we drank at his kitchen table. We discovered we shared southern origins, and we bonded over his stories of rural Mecklenburg County, Virginia, where he had spent summers with his grandparents.

Romare, or Romy, as I called him once I felt comfortable using his nickname, was an engaging storyteller who often expressed ideas through his tales. One centered on a woman who cleaned the Harlem building (owned by his mother) where his studio had once been located. During the harsh days of the Depression, prostitutes lined 125th Street and jingled keys to attract business. On his way to his studio, Romy encountered a particular woman jangling her keys; she called out to him, "Twenty-five cents" but, sensing his lack of interest, quickly reduced her demand to a dime, then a nickel. At last, in desperation, she called out, "Mister, just take me." Romy asked if she needed a job. He knew his politically active mother would want to help. The woman quickly said yes, and his mother hired her to clean the building.

A year or so later, Romy was sitting in front of a large blank canvas, stuck in a period of inactivity. From the corner of his studio the cleaning woman, broom in hand, spoke out: "Why don't you paint me?"

Romy turned with a dismissive expression but said nothing.

"I know what I look like," the woman said, "but if you can find beauty in me, you can call yourself a painter."

He immediately began and over time completed a painting of this woman. Romy always chose to see obstacles as opportunity, an idea he credited to the French artist Georges Braque. The greater the limitation, the more creative you must become to overcome it, he liked to say.

Over the years I too have come to rely on these words. Whenever equipment or circumstances fail me, his words become my mantra, and with hardly a glance back I refocus and seek out a solution by calling on my creativity to rescue me.

It saves time—and it has never failed me.

Don't Make Them

It was no small honor when the Exposure Group, a collective of dynamic African American photographers based in Washington, D.C., presented me with their 2002 Gordon Parks Legend Award. For me, Gordon Parks symbolizes excellence and achievement.

I first met Gordon in 1971, when he had finished his second movie, *The Learning Tree,* and was in preproduction for his next film, *Shaft*. He is an imposing figure, personally as well as professionally. Greeting me at the door to his Manhattan apartment, Gordon took me into his large living room with its commanding view of the East River. Surrounding us were couches arranged to take advantage of the

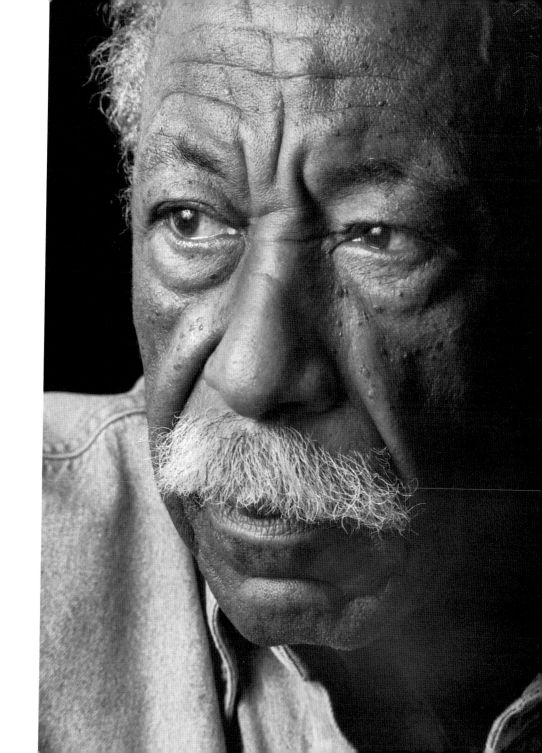

THE PHOTOGRAPHER
GORDON PARKS

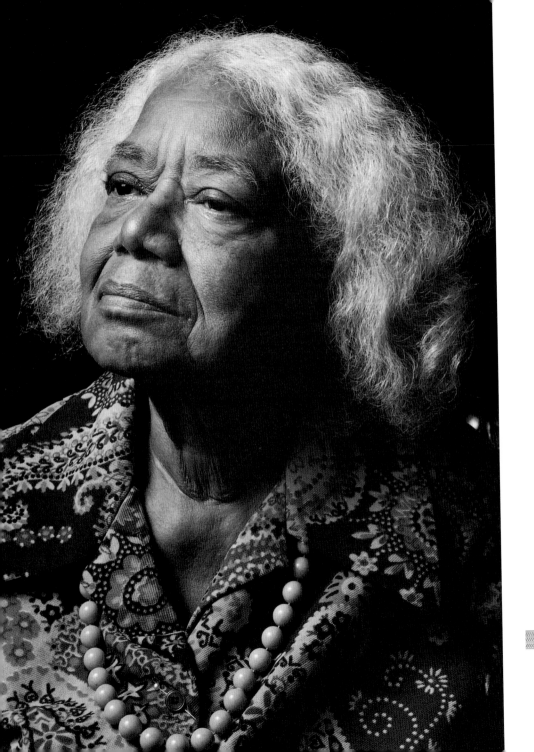

JOLENE FINNELL,
A MIDWESTERN ELDER

panoramic view, a grand piano, his photographs and paintings, and his countless awards, piled several deep on tabletops. Some of his photographs, enlarged to thirty by forty inches, made me feel I was in a personal museum.

I took my first photography book, *Black Woman*, to show Gordon. Offering words of encouragement, he began to talk about the business of art. An accomplished photographer who became a staffer for *Life* magazine, Gordon is an equally talented musician, filmmaker, writer, poet, and painter. When I brought up my passion to change the media's perception of African Americans, he gave me a piece of advice, arresting in its simplicity: "If your ethics demand that you not perpetuate negative images," he told me bluntly, "then don't make them." He went on to explain that if a photographer makes thirty-five dignified images and only one negative image, most editors will choose that one negative frame in a roll of thirty-six exposures. Only the rarest editors have the ability to overcome this societal bias.

Years later, when Gordon and I were again sitting in his comfortable living room, our talk was about the many things that make a good photograph. My mind was racing to composition, lighting, design, all the technical aspects, but Gordon was thinking metaphysically. "Great photographs are made with the heart, not necessarily with the eye," he told me.

Embracing this approach, I try to seek out images that make my heart smile.

My Cousin Connie

My cousin Connie is a gift. She and I met only a few years ago. She was visiting New York City and happened to pass through the photography department at *The New York Times*, where I work. When we were introduced, we recognized each other's last names. It was a long shot, but we started playing the "Do you know?" game. Astonishingly, we discovered we were related—on a side of my family I know almost nothing about. I did not meet my biological father until I was a teenager, and I guess it was just too late to establish any kind of bond. I am related to the New Brockton family I claim as my relatives, even the man I call Daddy, by my mother's marriage. But here was Connie; our paternal grandfathers had been brothers.

Here was a flesh-and-blood relative, walking into my life fully grown. We had a lot of catching up to do. Connie is a talented journalist. When I questioned her about her successful career, she said she was happy with her professional progress but would like the same

satisfaction in her personal life; she looks to marry and have children someday.

Young women don't get any smarter or more beautiful than my cousin Connie, who is in her mid-thirties, tall, slender, with the prettiest smile and a body that's straight from the glamour pages. When she walks into a room, men's eyes turn. Men hit on my cousin all the time, but she doesn't trust what they tell her. She claims, and I don't doubt, that she has heard every line invented. As her cousin, I have been deputized to give her some good leads. So far I have not been very helpful; all the eligible bachelors I know are already involved. Her response to this: "Yeah, when there is an available good man out there, every available woman knows about him."

Once she met a guy at her gym, where she works out early mornings to stay in shape. For weeks while he worked out, she knew he had her on his radar. Finally, one day he approached her when they were leaving the gym together. He asked for her phone number, but she insisted he give her his—her precaution against dating a man who lives with someone.

When she did call him and he asked her out, she wouldn't allow him to pick her up at her residence. They met downtown. "I often do this," she confessed, "to avoid having a new acquaintance know where I live."

When I asked how long it takes before she relaxes, she smiled but gave me no answer.

"Caution is good," I agreed, "but don't overlook intuition."

In 2000 I visited Cousin Connie in the Midwest, where she lives.

I was looking for people over seventy with white hair and countenances of dignity for my *Elder Grace* project. Inspired by P. H. Polk, I had been shooting elders ever since I first picked up a camera, but not until the 1990s, when I began making my portraits against a black backdrop, was I able to get a contract from a publisher. After *Elder Grace: The Nobility of Aging* was published and an acquaintance mentioned that P. H. Polk often used dark backgrounds, I recognized how much Mr. Polk's works had influenced this project. In some way the portraits are a tribute to my first mentor.

Connie told me she had found a perfect elder, a woman she had spotted attending a film festival. When she introduced me to Miss Jolene Finnell, I knew she was right. The woman fit my criteria perfectly. Connie and I went to her home, where I began shooting her portrait. Miss Jolene's house overflows with books, and she appears to be very comfortable living there alone with her dog. Looking around, my curious journalist cousin asked, "Miss Jolene, do you have children?"

"No," she answered, "I've never been married."

"Uh-oh," I muttered to myself. "Why did she say that word?" And sure enough, Connie was hooked and wanted to know more.

"So you've never been married," she repeated.

"No," Miss Jolene said, "but I've been engaged a couple of times."

At this point Connie's curiosity was insatiable. "What happened?" she demanded.

Miss Jolene cocked her head and looked my cousin straight in the eye, "Honey," she said, "something always happens. I don't know . . . maybe I was just too strong for them."

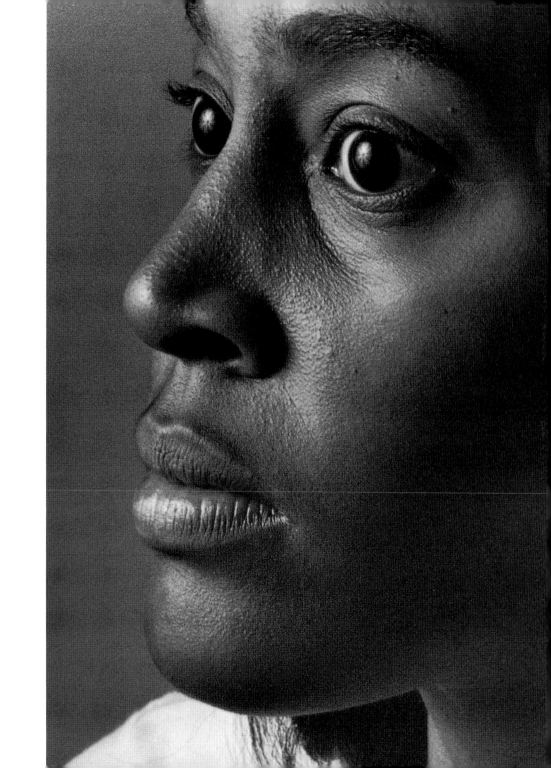

My cousin Connie

Silence filled the room, and I couldn't help wondering if Connie feared she was looking into a mirror—one she didn't want to contemplate, perhaps her worst nightmare. As it was, she had nothing more to say on the subject of marriage.

I finished Miss Jolene's portrait, and Connie and I left.

South *of the* Sun

His cries echoed emptiness and defeat. The man was slumped on the floor of a large room, sitting in a pool of his own blood. Next to him lay the razor blade he had used to open the veins in his wrists. It was clear he wanted to end the burden of living; emotional anguish numbed his physical pain.

His attempted suicide proved unsuccessful. Someone alerted 911, and the operators dispatched a New York City emergency medical service crew.

As a staff photographer for *The New York Times*, I was shadowing the EMS crew to document how these men and women save lives. The call was the first attempted suicide we had encountered together.

Suicide is difficult to cope with. People seem to fear it could be contagious. If it happened to you, could it happen to me? We raced through the streets, siren blaring, and I couldn't help wondering how I was going to deal with this man's tragedy. He might end up dead. But

I was there to document the crew's response to this event, not to save his life; that was out of my control.

As I walked through the apartment, fear numbed my body. Death lingered in the air and on the walls. The crew jumped into action, and we all breathed easier when we knew he was going to live. Now would come an even tougher time for him. He would have to face down whatever pain he was running away from.

This young man's attempt on his life hurtled me back to a few years before, when I had considered killing myself. In a dead first marriage and facing a court-imposed estrangement from my children, I felt lost in a sea of emotional pain. At the time there was a gun in the apartment, and I came to see it as a reliable friend, capable of rescuing me from my suffering. One day I took the gun out of hiding. I palmed the hard metal and carefully loaded all the chambers, even though one bullet would have been enough. I found a comfortable place to sit and started to raise the barrel, but then I decided to give myself a last request. I laid down the loaded gun and walked outside to our terrace, into daylight. I wanted to look into the face of the sun.

All my life I had been warned that the bright light could damage eyes, but that day I decided my eyes could feast on this forbidden pleasure. They wouldn't be needed much longer. As I stared into the brilliance, the center of the sun turned to liquefied silver. Rings of emanating light cascaded toward me. I heard a voice inside my head. It felt like the spirit of the sun was speaking to me: "Have faith; it's not over. There is a future for you."

I dropped my head and gazed at the ground, allowing my eyes to

OVERLOOKING THE ATLANTIC OCEAN

OVERLEAF: FISHERMEN RETURNING TO PORT AT CAPE COAST, GHANA

readjust. I no longer wanted to kill myself. Inside the apartment, I removed the shells from the loaded pistol and returned it to its hiding place.

I telephoned my friend Bert Andrews and we talked. He understood my pain and referred me to a therapist friend of his. An hour later I made my first appointment. I found the help I needed in therapy. Slowly, with much hard work, I discovered how to face my fears, heal myself, appreciate being alone, and, most important, remain connected to my children.

A New Beginning

CHAPTER SEVENTEEN

Looking back on my divorce—a time of personal crisis—it is easy to see the residue of this life-altering condition seeping into my professional life. My enthusiasm for my personal photo shoots diminished. I stopped filing my negatives; two years of work accumulated in cardboard boxes, unorganized contact sheets and negatives that I had no idea how to find. I reached a point where I lost clarity in my artistic direction.

In the early 1980s, in the middle of a workday—during down time between my assignments for *The New York Times*—I stopped by Cornell Capa's office in the International Center of Photography on Fifth Avenue. He made time for me, and we talked in his spacious corner office with its two large circular windows. Cornell's questions about my work brought home just how adrift I had become. Sensing my confusion and uncertainty, Cornell offered some tempting ideas to help structure and guide me. As I thought about his questions and ideas and how my

work fit or didn't fit them, I came to appreciate the body of work I had been accumulating all along. Becoming aware of what I didn't have, I realized that all my work reflected my search for African identity.

We African Americans have become disconnected from the understanding and complexities of our ancestral African culture. When I read popular accounts of our human history, I am blocked by the obsession of Western historians to disconnect from all but the recent past. The earliest humans lived in Africa, and the roots of Western philosophical and religious thought lie in Africa. My travels had already brought me to the ancient pyramids and tombs in Egypt, the rock churches of Ethiopia, and the ancient rites of the Dogon and Asante peoples. Fifteen working trips to Africa had heavily weighted my photography archive toward African culture. Even shooting in the United States, I instinctively sought out diasporan cultural links.

Out of my discussions with Cornell grew my next project, culled from my twenty-six years of photographing: a book on Africa and the African diaspora called *Feeling the Spirit: Searching the World for the People of Africa*. From my crisis of confidence came growth.

*T*HE PYRAMIDS AT GIZA, EGYPT

Water *of* Change

Pilgrimage *to the* Past

Fingering through the pages of my mother's encyclopedia at the age of ten, I made a discovery that has gnawed at my consciousness ever since. The picture of a doll—a Ushabti, as I discovered years later—in the image of a black child jumped off the page. In the mid-1950s, there were few black dolls. The one in the encyclopedia was from the past, the distant past: a figurine from an ancient Egyptian tomb.

I was struck by the familiarity of the features. Here, to me, was evidence of the existence of black people in a place and time of which I had no knowledge. I recognized something African about the doll, though the captions gave no such indication.

Not until nearly a decade later, when I went away to college, did I again give serious thought to other black people around the world. Through friendships with students from Africa, I came to appreciate the promise of Africa—a continent about which I had no clear understanding. I began to read the works of Ghana's Kwame Nkrumah,

A Ushabti

Kenya's Jomo Kenyatta, and Senegal's Leopold Senghor, among others. Still, Africa both fascinated and frightened me, and I couldn't let go of a lingering fear that Africa was "primitive"—a fashionable adjective that appeared two or three times in just about every article published on the subject in the 1950s and 1960s.

Amazingly, a simple African tale recounted by a professor of industrial relations inspired a profound moment of recognition and launched a lifelong mission. In this tale a father tells his young son a story about a hunter who stalks and kills a lion, the king of the jungle. "Why," asks the son, "doesn't the lion triumph and kill the man? He is stronger and has sharp claws and teeth." "The lion will win," responds the father, "when he writes his own story."

Years after attending segregated schools in the South, I appreciate how effectively my schoolteacher mother and other black educators worked to tell our story. They cobbled together, mostly by dint of their own research, threads of our African American past. They fleshed out and balanced our school curriculum, giving us our own heroes and martyrs. We learned early about Frederick Douglass, Sojourner Truth, Harriet Tubman, Denmark Vesey, Nat Turner.

When I first set foot in Africa, I was full of anticipation. Finally I was to discover for myself the parallel black reality I had long nourished in my imagination. I was exhilarated at suddenly finding myself in the majority. On that first trip, I began a lifelong study of the mannerisms, culture, and traditions of my people—mirror images of the people of my childhood. Americans, both blacks and whites, recognize little of the cultural richness of Africa.

THE SLAVE FORT AT CAPE COAST, GHANA

OVERLEAF: THE PYRAMIDS AT MEROE, IN THE NUBIAN DESERT, SUDAN

During the next three decades, I used my camera to see Africa beyond the skewed prism of colonialism and to discover for myself the monumental evidence of past civilizations. My first trips to East Africa brought me face to face with Ethiopia's twelfth-century rock-hewn Christian churches. Employing a technology similar to that used by ancient Egyptians at the temple at Abu Simbel, Ethiopians extracted stone from mountains to create holy sanctuaries.

In Egypt, I documented, in dozens of trips through its many layers of civilization, similarities with Ethiopian and other African cultures, exploring in-depth connections with the royal Asante kingdom in modern-day Ghana. The death of the Asante king in March 2000 and the installation of his successor a year later afforded me a rare glimpse into the customs of this ancient monarchy, whose people honor traditions emanating from ancient Egypt. Both kingships claim divine origin from the sun and moon, and their kings possess double souls. Both honor and worship ancestors and practice similar elaborate, protracted rituals surrounding death and mourning.

I find I am most at home in West Africa. I look more like the people there, and the red clay of the earth reminds me of the hills of Alabama. We African Americans suffer from collective amnesia. We know our ancestors came from Africa, most likely from West Africa, but most of us know little more. Like others before me, I made the pilgrimage to the numerous European forts that dotted the Atlantic coast of West Africa from Senegal to Angola during colonial times, with their dungeons for Africans captured and bound for the Americas. Incongruously, one such monument to evil stands on picturesque

The Church of St. George in the holy city of Lalibela, Ethiopia

Gorée Island, in Senegal. During my first visit there, I lingered in the Door of No Return, a dark passageway that once led from cramped dungeons to human-cargo ships. It is impossible to visit these "slave forts," as they were known, and not be profoundly shaken.

The ships that spirited our African ancestors across the Middle Passage left in their wake the largest cemetery in the world. Untold millions lie in watery graves at the bottom of the Atlantic Ocean. Tracing the routes of the Middle Passage, I began to explore the places in the Americas where the slave ships had unloaded their stolen cargo. At some of these destinations, surprisingly intact remnants of African culture still thrive.

In Suriname's maroon communities, Africans who escaped the bonds of slavery were able to reestablish a traditional African lifestyle in remote rain-forest settings far from their European captors. I experienced African traditions almost untouched by the intrusions of the modern world. Isolated for nearly two hundred years, the people here adhere to their ancient culture more intensely than most continental Africans do. In Brazil, Cuba, and Haiti, I photographed spiritual activities nearly identical to those I have documented in Senegal, Ghana, and Mali.

My mother and the elders in my small village in Alabama provided me with a unique look at African American history. Now it is up to us to reexamine and reconnect with what began so long ago in ancient Africa. The time has come to write our own story.

M'Dea

I gave my mother a gravestone on Mother's Day. We buried her in March 1993, and two months later the monument I ordered was placed on her grave in Hardshell Cemetery on the outskirts of New Brockton. The letters chiseled in the cold, hard granite convey my eternal gratitude to her; they read simply, "A great tree has fallen into God's hands." On one of my trips to Ghana, I saw a broadcast on local television of the obituary of an Asante chief. At the close, the chief was shown dancing and the frame froze with the words "A great tree has fallen." Subsequently I learned that these words proclaim the loss of someone greatly loved and admired.

I called her M'Dea, but her name was Varidee Loretta Higgins Smith, and she was my mother, the granddaughter of an enslaved couple, Sidney Lloyd and Viney Henry Clay. Orphaned at five during the influenza epidemic of the early 1900s and raised by brothers and sisters, she was one of only two out of thirteen children who went to college.

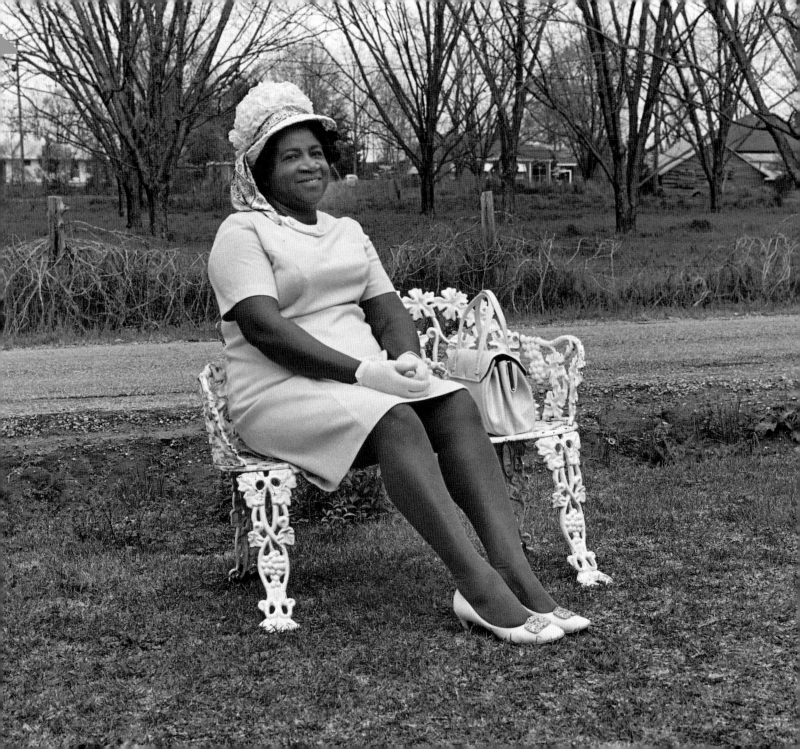

She owed that education to an academic scholarship and sacrificed money that her sisters earned cleaning the homes of whites in Fairhope, Alabama.

As a schoolteacher, she was an exacting mother—homework had to be done before any play. It was checked and redone if not perfectly completed. She insisted on jobs for me, daily at home and outside on Saturdays. In summer, there was a week of Bible school, followed by labor in the county fields where cotton, peanuts, tomatoes, and sugarcane grew—a choice I made to escape her domestic tyranny and be with my friends.

One night after dinner, M'Dea quietly let me know: "When the American Revolutionary War started, the first man to die for freedom from the crown of England was an African man, Crispus Attucks." I was barely nine and apparently ripe for that kind of knowledge, because I still remember those exact words. Another time she said, "You know this country has a national anthem, and the Negro has one too. It's called 'The Negro National Anthem,' written by a black man, James Weldon Johnson." And she taught me that anthem, which I proudly sing as each opportunity presents itself.

My mother's gift to me was to create in my mind a yearning to know and appreciate myself, my people, our history, and our future. Several months before her death, I visited for her seventy-first birthday. One night I took out a tape recorder and spent the next three hours listening to her tell her life story and the history of the family. I had no idea that this would be her last birthday, nor that listening to this tape would bring me some small comfort the night she died.

Since her death, her friends have surprised me with new knowledge

VARIDEE LORETTA HIGGINS
SMITH ON HER FRONT LAWN

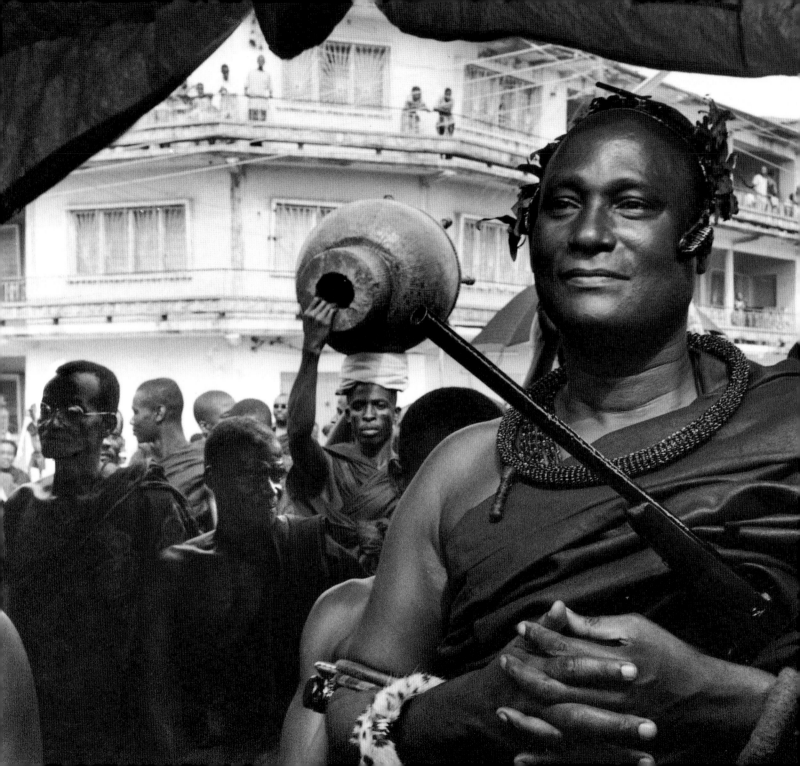

An Asante chief
in Kumasi, Ghana

of her. I received a letter from Mrs. Madie Finch, a friend of my mother's who moved away from Alabama when I was a teenager. This woman, with two children of her own, told me that when she and my mother were both new mothers, they made a pact that whichever of them lived the longest would stay in touch with the other's children. I discovered that I had been passed into the concern of my mother's choice for her substitute. Mrs. Finch asked me to allow her to fulfill this promise. I consented; I will enjoy this spiritual hand of my mother's memory, provided for me with her blessings.

At the graveside ceremony for M'Dea, my daughter, Nataki, and my son, Damani, asked to be able to put something inside the casket with their grandmother. Nataki placed a picture of her baby girl, Shaquila, a great-granddaughter never seen by her great-grandmother. My son removed his tie and laid it beside his grandmother before the lid was closed.

As we were sharing these moments, I remembered an African burial ceremony I had come across months before while photographing at the eighteenth-century African burial ground discovered in 1994 in lower Manhattan.

I placed my two children on one side of the casket, and I stood on the other. As we began taking turns passing Shaquila, the youngest in our family, across the casket that held the body of my mother, I said, "This first pass is for our ancestors, those who came before us." The second time: "This time is for those of us who are living, the survivors." And for the third and final pass, I said, "For those who will come after us."

We hugged, savoring the fusion of our spirits with the spirit of M'Dea.

A great tree had fallen.

A BURIAL AT HARDSHELL CEMETERY

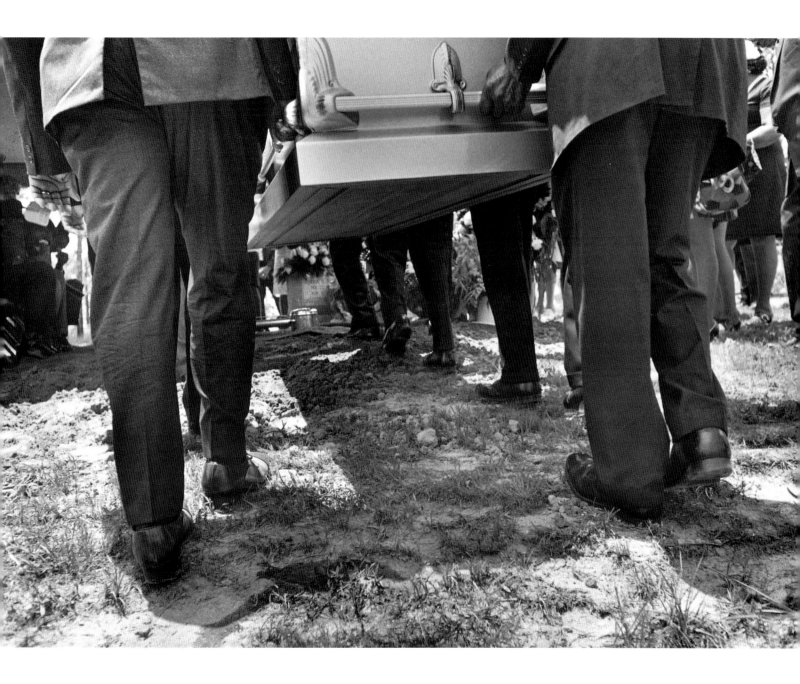

The Voice *of* Red

Red is a power color! It's dramatic, provocative, and seductive, and it commands attention. Red fabric shimmers against deep black skin like fire glowing in the night. My mother was well acquainted with the awesome power of red. She understood its mysterious force so well that she wanted to protect me from it. From as far back as I can remember, she declared her everlasting enmity for the color. "It's too loud and too ethnic," she always said. As a child, I was not allowed to wear a single piece of clothing that was solid red!

I grew up puzzled and annoyed by my mother's inexplicable campaign to discredit the color red, but her influence left its mark on me. It wasn't until I was twenty-seven years old that I finally broke free of her prohibition. It happened in Africa.

My fifth trip to the continent brought me to Ethiopia, where a meeting of the Organization of African Unity promised an opportunity to photograph African heads of state. One day, as I waited at the Addis

Ababa airport for a glimpse of arriving dignitaries, my attention was pulled from the action around the arriving airplanes to a group of men making their way across the tarmac. I could sense the power of one man in particular before I could even see him.

Although he was a person of such small stature that he was dwarfed by those alongside him, something about his aura so profoundly moved me that I lowered the camera so I could see with both eyes. Only after he passed me did I learn that I had been in the presence of His Majesty Haile Selassie, the emperor of Ethiopia.

That seconds-long encounter set me on a quest to discover all I could about His Majesty and his country. Among the smorgasbord of new knowledge I devoured over the course of years was a detail about the pageantry in Haile Selassie's palace. The emperor, I was told by a daughter of his minister of defense, held court while standing on a red cushion at the foot of his throne.

That did it for me. My conflicted feelings about the color red vanished. I began wearing red socks, and I continue to do so in honor of His Majesty. Eventually I would be seen sporting solid red shirts, sweaters, jackets, hats, scarves, belts, and even red suspenders, according to my mood. From then on I never gave much thought to my mother's crusade against red. Not until recently, anyway.

A year after her death, I traveled to Fairhope in southwestern Alabama for a family reunion. Surrounded by my relatives, I was blessed with hearing story after story about the woman who raised me. At some point I brought up the subject of my mother's curious hatred of the color red. For a moment everyone in the room fell silent and stared at me.

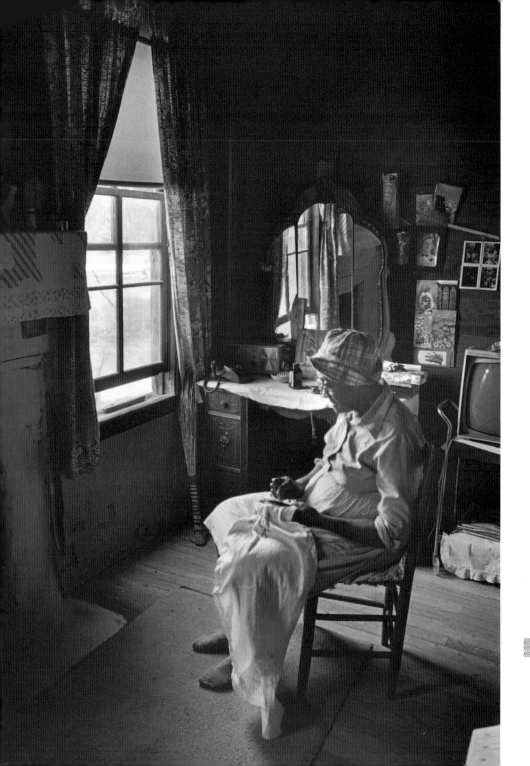

An Alabama woman

DOING NEEDLEWORK

"You don't know?" someone finally asked.

Red, I was told, had altered our family history. For us, it meant the difference between slavery and freedom. My great-great-grandfather, as the story goes, had just reached puberty and was alone in the African forest, performing the initiation rituals demanded by his village. In the distance he spotted a red banner that stood out against the green backdrop, and he became distracted. When he went to investigate, his life—as well as the lives of all his descendants—was changed forever. The banner belonged to a band of slave hunters, who seized this strong young man and shipped him across the Atlantic to the Americas. In spite of numerous attempts to escape, he remained enslaved until he was finally able to free himself by joining the Union Army during the Civil War.

To this day, I don't understand why my mother never shared this rich family legend. But I do understand her strong feelings about wearing such a bold color. When I was growing up in the racist Deep South, a black boy had to be careful not to call too much attention to himself. My mother's protective instincts were working overtime, and for that I'm grateful.

Today I reclaim red, and all the loudness, boldness, and ethnicity it evokes. I see it reflected in each of the flags of the countries of Africa. It is the color associated with the ancient kingdoms of Nubia and Kush, and with Shango, the powerful West African deity of lightning and thunder, who symbolizes the finger and voice of the Supreme One. Red saturates our African culture and is woven throughout the stories that make up our legacy.

For me, red represents a direct connection to my past.

A Father's Rite

CHAPTER TWENTY-ONE

When my son was twenty, I took him to Africa. For three weeks we explored together the past and present of our people in Egypt and Ethiopia. I wanted him to see what I regard as the land of his heritage; I wanted him to experience the ecstasy I felt on my first visit to Africa, when I too was in my twenties.

I had envisioned a rite of passage for my son; what transpired between us became a turning point in our relationship, for me as his father, and for him as well.

Being a father seems to require skills that were never taught to me. Throughout the years my son and daughter were growing up, I often felt as if I were in a boat, slipping along on the water during a dark night without a lamp or a lighthouse to guide me. I felt like an imposter. The child-rearing philosophy of the man I call Daddy, was more hands-off than hands-on. At nineteen I sought out my biological father, whom I had never even laid eyes on. Perhaps because we had no history

My son, Damani, in the highlands of Ethiopia

132

together, our relationship never flowered. As a result, I was determined to take the role of father seriously.

When my son was nine years old and my daughter was eleven, their mother and I divorced, and it nearly sank the already drifting boat. With divorce often comes anger, a welter of conflicting feelings and much pain for everybody. New York State court-restricted visitations for a father can reduce his relationship with his children to that of an uncle. Growing up without a relationship with my biological father, I was determined to maintain as much contact with my children as the law would allow.

For my fifteenth trip to Africa, in July 1992, to photograph the reinterment of His Majesty Haile Selassie on what would have been his one hundredth birthday, I decided to ask Damani to come along as my assistant. Damani, who had locked his hair then, shares my love of His Majesty and of reggae, the music of the Rastafarians, who worship Selassie. I added to our itinerary a stopover in Egypt so that my son could also see the pyramids, temples, and tombs of our ancestors.

Haile Selassie's reinterment was postponed by the new Ethiopian regime about two weeks before we were to arrive. Though deeply disappointed, neither Damani nor I considered canceling our trip, nor did the thousands of Rastafarians who annually gather for Selassie's birthday. While we were in Ethiopia, my son in his locks blended in with the local population; his enthusiasm for this venerable African country warmed my heart. On a four-day trip to the ancient sacred city of Lalibela, where in the twelfth century churches were hewn out of the surrounding mountains, I had a dream. In my dream, I saw two men, one

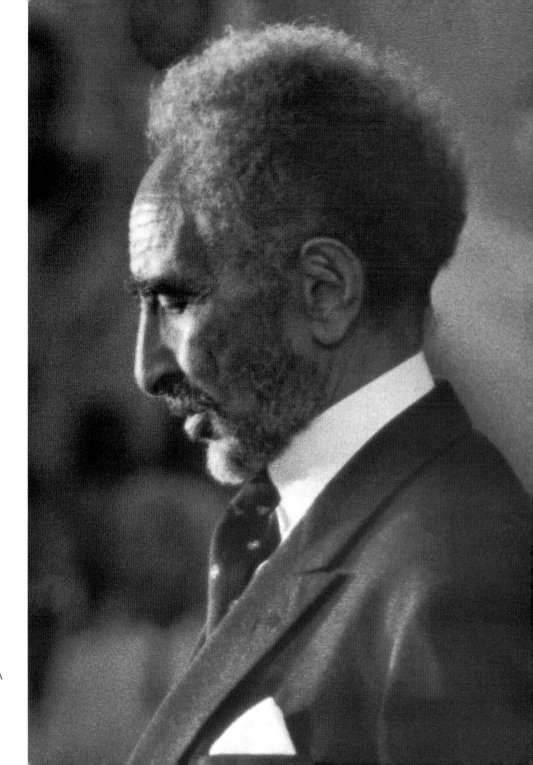

*H*IS MAJESTY HAILE SELASSIE,
THE LAST EMPEROR OF ETHIOPIA

older and one younger, facing each other against a backdrop of temples and pyramids. The father was speaking as he anointed the head of his son.

I became enamored of the possibility of enacting a ceremony with my son in Africa. For the next six days I privately wondered what words to use in such a ceremony. Gradually the words came to me. By the time we arrived in Cairo, I was ready. I told my son that there was a ceremony that I wanted to perform with him in the tombs at Thebes. His eyes shone with anticipation. But I wondered if he would still be receptive after my next statement. In the dream, I remembered, the son was anointed with a dry substance. I took this to mean powder rather than oil. But what powder? I ruled out ground herbs and flowers, and finally settled on sand. Sand represents the Sahara, and sand also contains the remains of the ancient people of pharaonic Egypt. That made metaphysical sense to me, but in the real world, young adults— and almost anybody, for that matter—are disinclined to have sand poured on their hair.

"I will need sand to anoint your head," I told my son.

"Sand?" he asked hesitantly. "How much?"

"Just a little. You can put some in a film canister." We both knew a 35mm film canister wouldn't hold much sand. "Take the canister and find sand you feel special about, and I'll use that."

Once Damani was in control of the amount of sand and where it would come from, he decided to take some from the desert in the shadow of the pyramids in Cairo. Days later, when we reached Luxor, he collected more from around the remains of the Temple of Karnak— one of the largest, oldest stone temples in the world.

A FATHER PRAYING OVER HIS SON AT SUNRISE ON A BEACH IN ACCRA, GHANA

137

The next afternoon we sailed across the Nile to Luxor and the Valley of the Kings, a basin formed by towering mountains. From the heavenly perch of the ancient Egyptian deities, the valley resembles a huge bowl to which there is one narrow entrance, flanked by more tall peaks. The tombs of the pharaohs are hewn into the lower parts of the mountains that form the basin. Inside each tomb, six-foot-high passageways lead down several hundred feet into the solid rock. The scene that greets modern visitors to these sacred chambers is astonishing: ornately painted walls reveal images of animals, people, and scenes that were part of the real and imaginary lives of pharaonic Egyptians. It was here, inside one of the tombs of an Eighteenth Dynasty pharaoh, that I decided to perform the ceremony revealed to me in my dream in Ethiopia.

In front of an enormous wall painting of Osiris, the deity of resurrection, my son and I faced each other. I poured the sand he had collected into the palm of my left hand, and with my right I anointed the top of his head with this sand. Looking into his eyes, I said: "I, your father, anoint the crown of your head with the soil of Africa. This piece of earth is a symbol of the lives of your ancestors. It is a bonding of their lives to yours. Like your father, you too are African. We are Africans not because we were born in Africa, but because Africa was born in us. Look around you and behold us in our greatness. Greatness is an African possibility; you can make it yours. So here, in the company of those great ones who have waited patiently for your visit, you are loved, you are encouraged. Our faces shine toward yours. Go forward; may you live long, may you prosper and have health."

THE TOMB OF MERENPTAH IN THE VALLEY OF THE KINGS, LUXOR, EGYPT

A column in Karnak Temple, Luxor, Egypt

We hugged each other, enjoying the specialness of the moment. Leaving him alone inside the tomb to meditate, I walked back toward the light and waited for him outside on the valley floor.

Here in the land of our ancient fathers, in the tomb of one of the great fathers of the ancient Egyptian empire, my perception of what it means to be a father became clearer. Sharing this time in this place with my son made me aware of all the fathers before me. My son, like all sons, carries the ambitions of succeeding generations, waiting to unfold. For him, I am the link to his past, and he is my link to the future.

alling Forth *the* Spirit

CHAPTER TWENTY-TWO

Religion was born in East Africa. The ceremonies and rites that mold the African spiritual landscape have survived for millennia. In Africa, ancient ceremonies still hold the imagination of a people who live under the biggest skies and who enjoy the most dramatic sunrises and sunsets in an environment still anchored in the immensity of nature.

The making and nurturing of a community, a society, ultimately depends upon shared belief. It is what they believe that separates the insiders from those outside.

For Africans born in the Western Hemisphere—descendants of enslaved ancestors from Africa—our spiritual heritage has been interrupted. Awareness of origin gives us the authority to create our own greater future. Our severed links are in dire need of repair. In order to advance, it is vital that we embrace the unity of African spirituality. Ancient religious thought and practice as an organic whole

The Asante king's royal drummers in Kumasi, Ghana

*T*HE MAAFA CEREMONY,
BROOKLYN, NEW YORK

is embedded in the worship of the ancient Egyptians, the foundation of the Judeo-Christian tradition.

African theology informs the Bible. The creation story, the Ten Commandments, and many proverbs and psalms are clearly borrowed from African theological doctrine as found in ancient Egyptian sacred texts. North Africa is central to the Bible; it is the religious stage on which all the formative drama that gives the Bible meaning was performed. Abraham and his family, fleeing the famine in Ur, were saved from starvation by the rich harvest in Egypt. Joseph, after being sold by his brothers into slavery, was given freedom by the pharaoh and the highest office in the land. Moses was rescued by another African, the pharaoh's daughter, and Jesus Christ and his family escaped a massacre in Bethlehem with their flight into Africa.

North Africans chiseled a body of their sacred texts into the stone walls and ceilings of the tomb of Pharaoh Unas in 2300 B.C.E., at Saqqara in Kemet, the ancient name for Egypt. However, religion began long before the civilization of Kemet. It can be traced farther back to the ancient people of the highlands of Kush (Ethiopia). From here religious thought migrated north down the River Nile through Axum and Nubia (Sudan), reaching its apex of theological expression in Kemet. This faith, like all traditional African faiths, even today, rests on a foundation of nature and solar theology.

Vestiges of the earliest beliefs and symbolism are apparent in various forms of traditional religions still practiced throughout Africa and in the diaspora. The bridge cultures of Erecha in Ethiopia, the Nuba in southern Sudan, the Dogon in Mali, the Asante in Ghana, the Yoruba

in Dahomey, the Nok in Nigeria, Vodun in Haiti, and Candomblé in Brazil offer living visualizations of this first faith. These traditional religions are the pieces that when combined make up the whole of a spiritual quilt—the earliest religion that flowered in ancient Africa.

Religious ceremonies recognize the human struggle to embrace spirituality. How we engage in that struggle may differ, but the emotions evoked are universal and our human birthright.

A Long Sleep

CHAPTER TWENTY-THREE

Even in New York City, where I live, remnants of African culture survive. And new ceremonies are being forged to honor those once forgotten. For over four hundred years our ancestors were sucked through the dungeons of the slave forts along the West African coast. Millions—some 15 percent—of those captured and transported died on the forced ocean voyage. The bottom of the Atlantic Ocean between Africa and the Americas became their vast cemetery.

Taking to heart the words of the writer and activist Toni Cade Bambara that it is "unacceptable that there is no holiday or statue or ceremony that marks the millions of Africans who left the African continent on slave ships of the Middle Passage, but who died along the way," Akeem, the coordinator of cultural programming at Medgar Evers College, organized a vigil at the edge of the Atlantic Ocean in Coney Island. Today this annual tribute takes place on the Saturday of a Juneteenth week. (The Emancipation Proclamation, ending slavery in

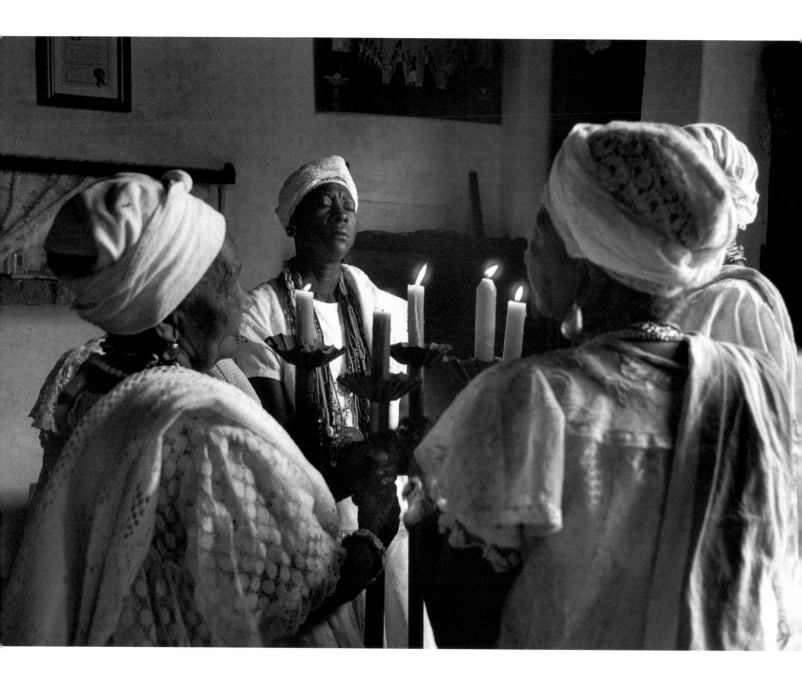

the United States, became effective on January 1, 1863; the advancing Union Army carried the order south as it slowly defeated the Confederate Army. Six months later, in the middle weeks of June—Juneteenth—news reached beyond the Mississippi River.)

The inaugural "Tribute to Our Ancestors of the Middle Passage" took place in 1989. I first documented it in 1990. The ceremony is held in honor of Yemanja, the Yoruba deity of the sea. It opens with a libation poured by African American priests and priestesses, during which the names of West African peoples and African American warriors for liberty are called out. At the close of the ceremony a final offering is made to Yemanja, beseeching her to watch over the spirits of our lost ancestors.

Those who did survive the Middle Passage, as well as their descendants, faced a forbidding life in a new land. Upon death they were committed to the earth for much-needed relief in a hostile and foreign country. The still living held them dear and treated their graves with acts of love.

For a long time these Africans slumbered in our midst without our knowledge. In 1992, construction in lower Manhattan unearthed the graves of eighteenth-century African residents, both free and enslaved. Of three hundred graves found, three of the skeletons had arms crossing their chests, a position I recognized from Egyptian mummies and statues—the sacred sign of worship. This gesture, called the sign of nullification, signifies the canceling of negative energy with positive. The three graves suggest that these first Africans brought with them their ancient belief in traditional African religion.

THE BOA MORTE SISTERHOOD
IN CACHOEIRA, BRAZIL

It was moving to witness these extraordinary discoveries. Weekly, individual and collective vigils—ceremonies of connection involving flowers and candles—were held to honor the long dead at the New York African Burial Ground. Living spirits aboveground communed with the spirits belowground. Christians, Muslims, atheists, and cultural nationalists all held their own individual ceremonies at the perimeter fence.

As I watched these, I began to feel something was missing. During the late 1980s and early 1990s I had concentrated on documenting the many expressions of African traditional religion practiced in parts of Africa, Brazil, Haiti, and Puerto Rico as well as right in New York City. I felt that a ceremony performed by people worshipping in the ancient faith needed to take place, and I wanted it to happen at an actual gravesite. I contacted a priest and priestess from the Shrine of Ptah in Brooklyn, who agreed with me. Now my task was to get clearance from the General Services Administration, which managed the site. It surprised me how so simple a request could cause such consternation; it was weeks before I got permission. By then, there were only six graves still with unexcavated bones. I had to move fast.

Two days later, when only one grave was still intact, I led the priest and priestess onto the site. Solemnly they performed the libation to bless the spirits of the dead. With this last ceremony, I believe we finally acknowledged the faiths of everybody who was buried here throughout the 1700s.

A few years later I received a call from a member of Reverend Johnny Youngblood's St. Paul Baptist Church in Brooklyn. Long an

 THE AFRICAN BURIAL GROUND CEREMONY, NEW YORK CITY

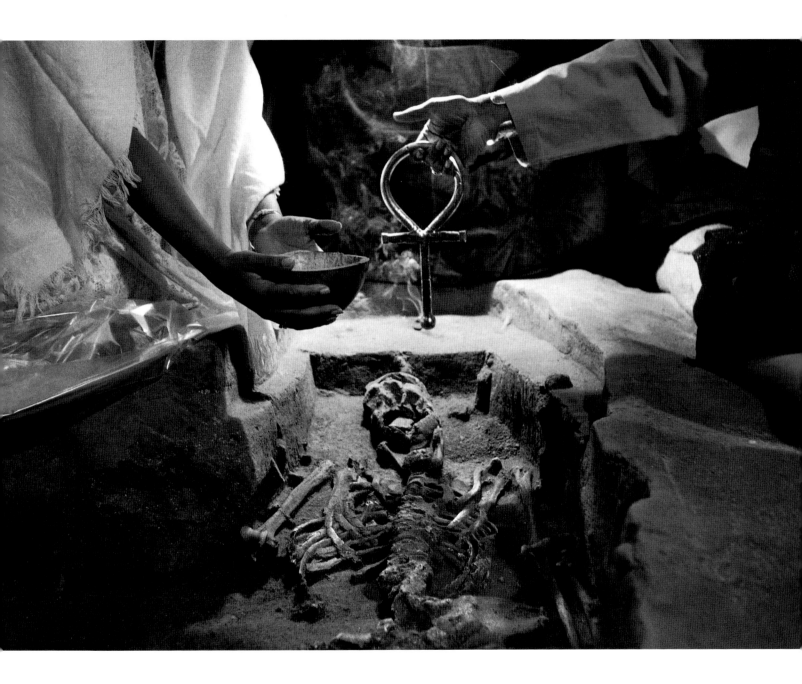

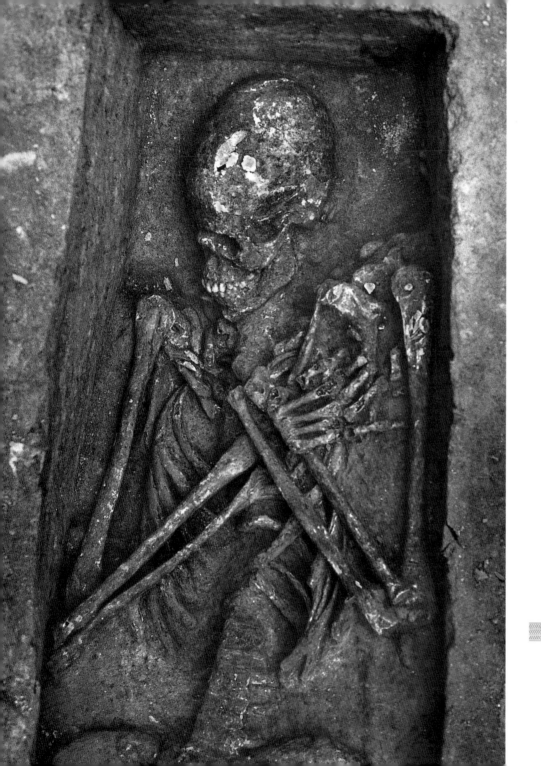

CROSSED ARMS IN THE
AFRICAN BURIAL GROUND,
NEW YORK CITY

activist, Reverend Youngblood was fashioning an African-centric ceremony designed to defeat the crippling effects that slavery and racism hold over Western-born Africans. The pastor was searching for a redemptive ritual that would be spiritually embracing and symbolically mark a new beginning. During my work documenting African religious rituals, I had come across a Brazilian purification ceremony in which popcorn was used for ritual cleansing, which resonated with Reverend Youngblood.

In 1998, Reverend Youngblood's celebration, called Maafa (a Swahili word for disaster or holocaust), came into being. Made up of discussions, lectures, dance, drumming, and theater as well as healing and purification rituals, the weeklong annual event examines this most painful part of our history using religious pageantry.

For me, religious ceremonies are the ultimate spiritual drama. With them, we reenact our spiritual history. They become the doorway to our collective experience; they tie our present to our history to refocus our future.

So Far *by* Faith

Once I rented a house in Accra, Ghana—a mansion, by my standards. It had been occupied by the administrator of the Ford Foundation and was staffed with a maid and a cook who doubled as a gardener. The sizable grounds were set back from the main road and included a swimming pool.

I was anxious to be out photographing one morning, and my car and driver were late. In foreign countries, I hire someone to drive for me so that I can concentrate on finding picture possibilities and not risk accidents or hassling by police because I might not know the local driving habits. Pacing back and forth in front of the house, I noticed a narrow footpath slicing through a field of dense grass to the highway. I took the path and waited another twenty minutes or so by the roadside, but no car arrived. So I started back to the house along the same path.

Halfway there, I passed a man carrying a machete and we nodded.

Just ten feet farther along the path, I heard a great commotion behind me and, turning, saw the man striking the ground repeatedly with his machete. I walked back. "What are you doing?" I asked before I saw *it*— an enormous black snake, more than six feet long. Undisturbed, the man told me he had just killed a black mamba.

I did not share his calm. Where was the snake when I passed? Why hadn't it attacked me? But most frightening, where had my mind been? Growing up in Alabama, I had been taught over and over again to search the grass for snakes, especially high grass.

My cool companion continued. "If this snake bites you, it attacks your nervous system and you have only enough time to cry out to God before you die."

It was a humbling thought.

From Floor to Ceiling

Hearing about sandstorms did not prepare me for their mysterious unpredictability. Four hours before sunset in the middle of a brilliantly blue afternoon in the Libyan town of Benghazi, the sky began to darken. It felt ominous from the start. Looking out across the desert, I watched a curtain of sand, stretching horizontally the length of the horizon and vertically from the desert floor all the way up into the clouds, advancing toward me. The air was charged. Visibility dropped from several miles to one, then to half a mile, to one thousand feet, one hundred, fifty, then to nearly nothing. All around me swirling currents of air sucked up sand

OVERLEAF: *A* SANDSTORM FORMING IN THE SAHARA DESERT, NIGER

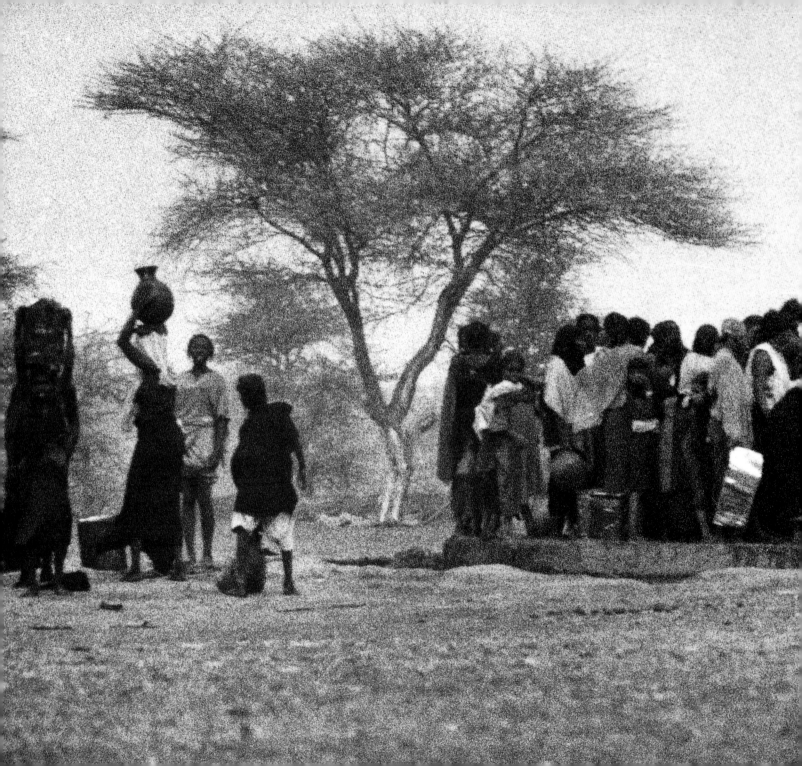

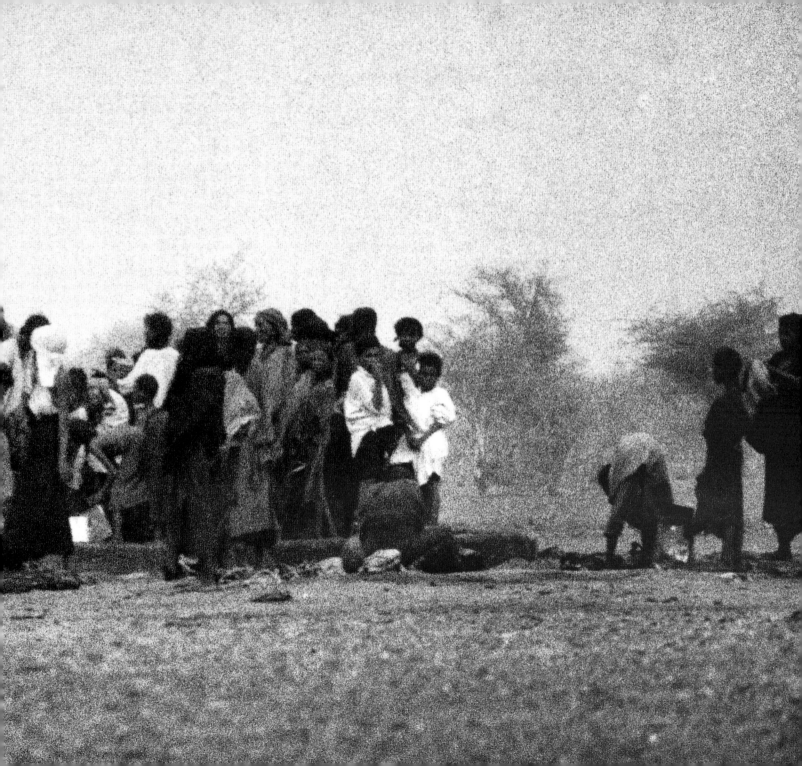

to feed the greedy, unstoppable storm. Inside the churning sand, fragments of scattered light reflected brown.

I pulled out a handkerchief and held it to my face, covering my nose and mouth. The gritty sand pounded against all my exposed skin. I squinted to protect my eyes. Stretching out an arm, I noted with alarm that I could no longer see my fist. Visibility was restricted to inches.

Now, perhaps too late, it was time to panic. Luckily, I was no more than twelve feet away from my hotel, and I have an excellent sense of direction. Engulfed by the moving desert, I set out blindly to retrace my steps. After what seemed like enough time to cover thirty feet, I finally made contact with familiar details of my hotel compound. Safely inside the building, I learned that sandstorms can last for a few hours, for days, even for weeks. Their duration depends on the depth of the storm, a factor incomprehensible to all but the most experienced.

That storm raged through the night and into the next morning; until then, I stayed indoors.

A Mighty River

I never learned how to swim, nor to tread water. Not knowing how to swim doesn't trouble me. Maybe one day I will take the plunge. I turned down an offer once to join my wife, Betsy, and stepdaughter, Elizabeth, whitewater rafting on the Green River in Utah. They assured me that everyone was required to wear life jackets, so swimming was not a prerequisite. I still declined.

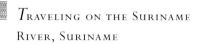
TRAVELING ON THE SURINAME
RIVER, SURINAME

Toward the end of that same year Betsy and I took off for Paramaribo, Suriname, in equatorial South America. I had learned through research that pockets of ancient African culture even more authentic than what I had documented in Africa existed here. I planned to live with and photograph the Saramakas, deep in the Suriname rain forest. Centuries ago, their ancestors escaped enslavement from Dutch plantations and followed the Suriname River into the jungle interior. The river, choked with huge boulders and ruled by swift currents, hindered battalions of government soldiers from effectively pursuing the escapees. Those who remained undetected reestablished the life they had lived before being brutally uprooted from the African continent. For centuries they were left alone, forgotten by the outside world.

Betsy and I, accompanied by our guide, flew about a hundred miles south from Paramaribo in a light plane. Our destination was a clearing in the rain forest, where Saramaka boatmen waited to carry us to their village, Goense. The only means of transport were dugout canoes rigged with five-horsepower motors. Two men were required to handle each of the long wooden boats; one ran the motor, and the other, called the stickman, used a long oar to direct our passage through treacherous swirls and around submerged boulders—and perhaps, although I never saw it, make last-minute corrections if we came too close to danger.

My wife told me later that I sat very still in our canoe, with an outward calm surrounding me. All I could do to put my trembling heart at ease was to pray to the Spirit that is always with me. Life jackets were not an option. There simply weren't any. Halfway though our hour-long journey downstream, the question of what to do if the boat overturned

was raised. Our boat handlers clearly had the utmost confidence in their abilities—less so in our chance of survival should mishap befall us. The strength of the current makes even swimming to the bank challenging—that is, so long as your head doesn't collide with a boulder first. And then there were the piranhas that feast in the river . . .

Arriving at the village of Goense, I stepped out of the canoe quite relieved—and ready to work. We ventured out onto the river several more times during our stay with the Saramakas, the river being the only direct link among villages. By the end of the trip, I was almost feeling at ease on the water, secure in the expertise of our hosts.

My comfort level on—and in—the Suriname River amazed even me. Living in the rain forest along the equator is a hot, sticky experience, relieved only by refreshing baths. Our village, with neatly swept dirt paths and beautifully ornate small wooden buildings, had no electricity or plumbing, so we, like the rest of the residents, delighted in the river's cooling water each morning and every evening. My apprehension over piranhas lessened when I was told that these fish favor fast-moving water, not the slower, calmer water that laps the banks. I gained courage watching the villagers. Twice each day I walked out into the river, trusting that the Spirit would protect me just as it protected the people of Goense.

In the Morning

When I arrived in Accra, Ghana, I went first to the American Embassy.
I find that Americans living abroad often have valuable knowledge about
the customs, traditions, and noteworthy ceremonies and events of their
host countries, and sometimes friendships develop from these
encounters. My friendship with Danny McGaffie, who was the cultural
attaché at the American Embassy in Accra, began that afternoon in 1973.
Today he is one of many friends I count on for advice when I travel.

The following year I stayed with Danny, his wife, Nell, and their
baby. Danny had rented a luxurious house in Accra with plenty of extra
bedrooms for visiting family and friends. One Friday evening during my
stay, he invited me to join him at a local club to listen to high-life music.
I loved the distinctive rhythm and appreciated being around the spirited
clubgoers. Halfway through the evening, an elegant young woman
caught my eye. I was taken with the idea of making graceful nudes with
her as my model. I envisioned shooting her on the secluded terrace at

ABENA, IN ACCRA, GHANA

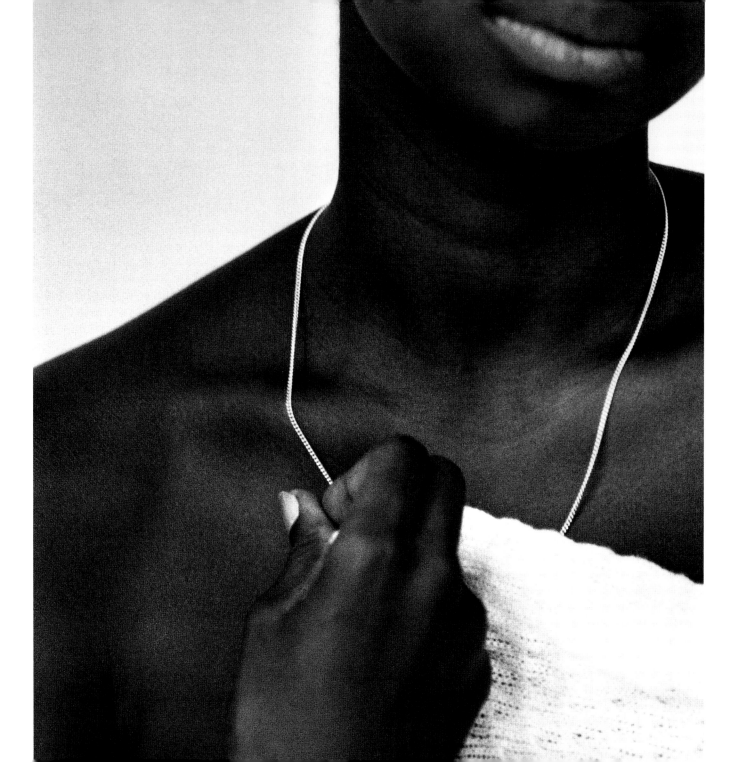

the back of Danny's house; daylight was my only option, since I carried no studio lights with me.

After sharing my plan with Danny, I made my way over to talk with her. She told me her name was Abena. I said I wanted to make photographs of her body nude and asked how she felt about the idea. Encouraged by her seeming agreement, I gave her my phone number and asked her to call me to set up a session for the next day.

I expected to hear from her, but Danny was not surprised at all when she didn't contact me. He suggested that my request might be competing with her business. It just had not occurred to me that her presence at the club was anything other than recreational.

The following evening Danny accompanied me when I returned to the club to look for Abena. Sure enough, she was there. I asked what she would charge to allow me to photograph her in the morning. She named a price and I agreed. The next morning we ate breakfast together before I took her out to the terrace to work.

To make incredible nudes, I believe a photographer must see the human body as form, with plateaus, peaks, and valleys. As I worked that morning, I knew I had found an amazing model. Her long body, beautiful black skin, and elegant countenance all came together into the landscape designs my mind had envisioned.

When we finished, she seemed happy and surprised that I had required her simply to pose for photographs. I was pleased with the photographs I had made, and thanked her.

With her money in hand, Abena slipped away into the bright daylight of a quiet Sunday morning in Accra.

Building Bridges

CHAPTER TWENTY-SIX

As a teenager I loved hunting on those winter nights with my father, Johnny Frank Smith, and my great-uncle March Forth McGowan. They had three eager hunting dogs; our prey were nocturnal creatures—possums and raccoons. In the evening my father would drive us to a wooded location, where we piled out of the front seat and let the dogs out the back. After filling their pockets with shells, my father and great-uncle shouldered their twelve- and sixteen-gauge shotguns. I carried the big flashlight for them and a candy bar for me. We would go deep into the woods before letting the dogs off their leashes. Their excited, high-pitched yelps told us when they had picked up the fresh scent of prey.

When the dogs discovered a trail, Uncle Forth encouraged them to chase the animal, and we set out in hot pursuit. Surrounded by barking dogs and in the company of serious hunters, I came to appreciate hunting as discovery—pursuing the game being more

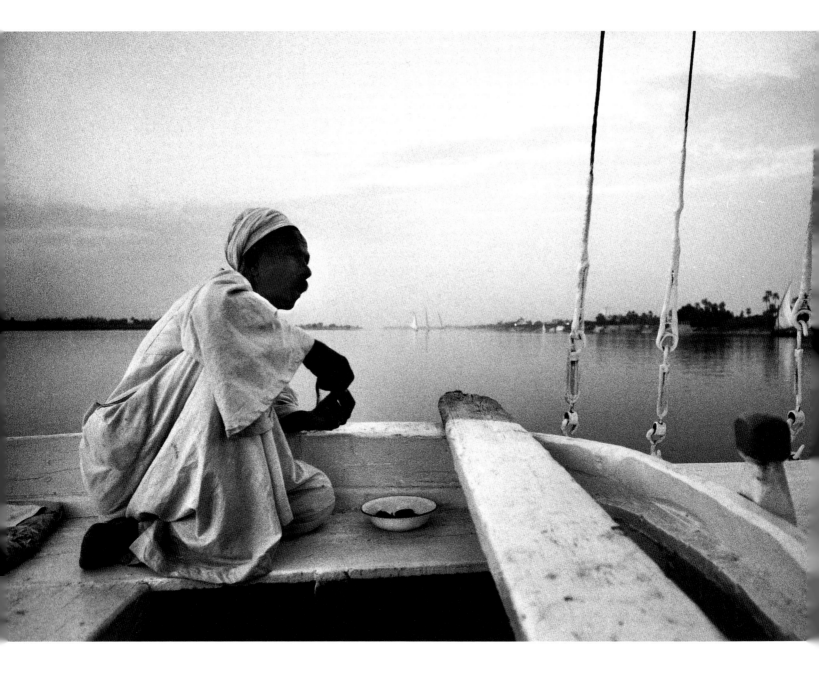

thrilling than bagging it. We came together on those cold, clear nights, bonded by trust, men and dogs in search of a shared goal.

The Drink

One day in my high school civics class, our teacher, Mr. Bernest Brooks, explained how important it is for all our people to register and exercise the right to vote. He began by detailing the voter registration form and the information required to complete it. Then he shared with us an episode from his own life, when he was registering voters.

One Saturday he approached two men enjoying a bottle of moonshine outside a pool hall. His request to register them to vote fell on deaf ears. The men barely shook their heads before resuming their conversation. Frustrated, Mr. Brooks blurted out, "Fellas, we really need your help." To this, one of the men extended the bottle from which they were both drinking. Mr. Brooks, who was not a drinking man, tipped the bottle up to his lips and pretended to take a sip of the strong liquor. When the men's conversation resumed, he joined in. After a while he steered their talk back to voting, and this time the men agreed. Mr. Brooks registered them right then and there.

What he did that afternoon, Mr. Brooks told the class, was to establish a "bridge of trust." With a swig of liquor, he was able to make two strangers feel comfortable enough to hear what he had to say.

SAILING ON THE NILE RIVER, LUXOR, EGYPT

OVERLEAF: A BEND IN THE NILE RIVER AT THE THIRD CATARACT, SUDAN

169

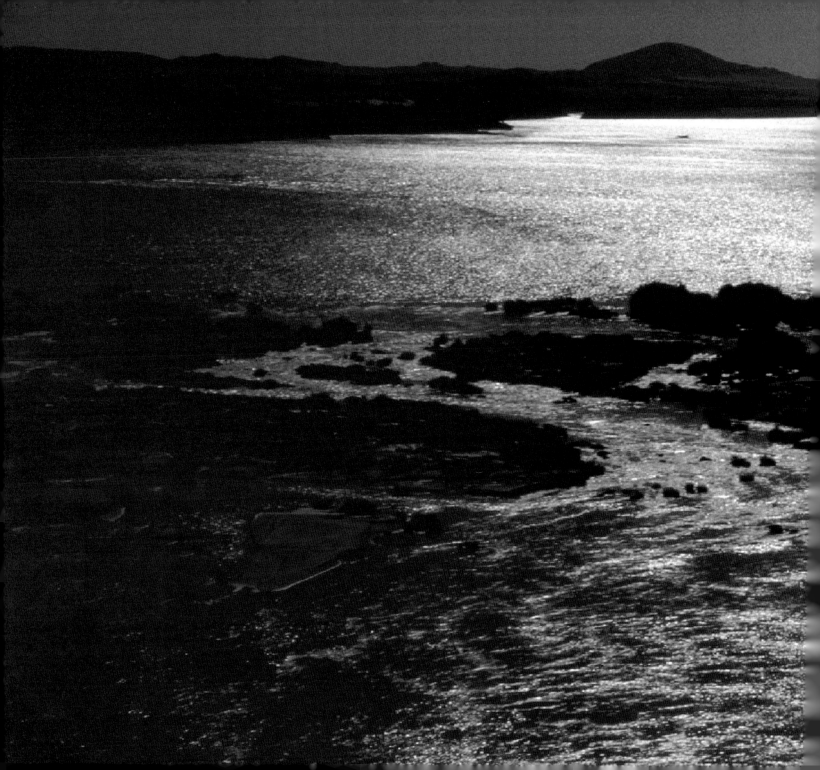

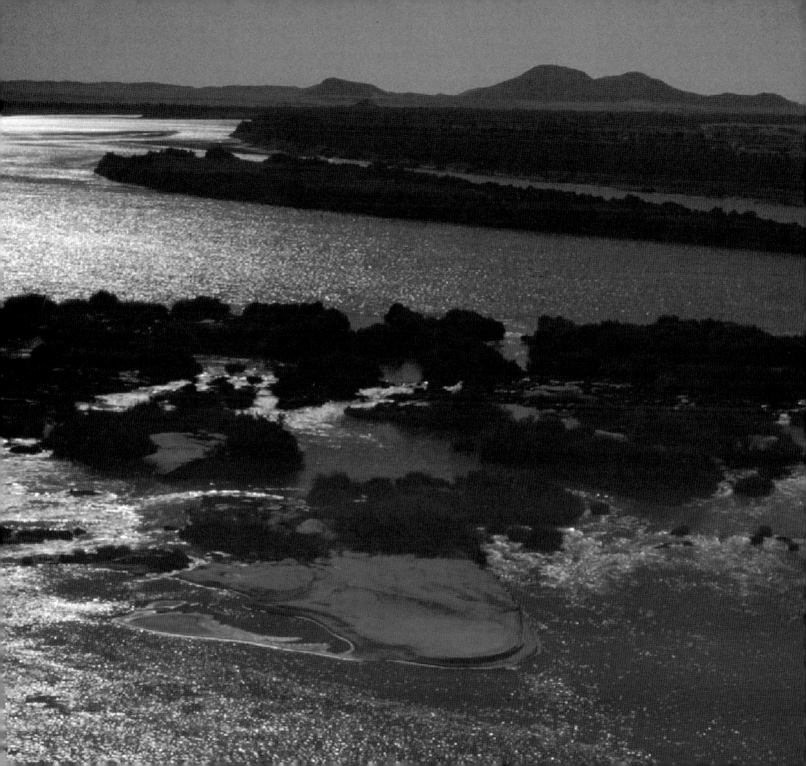

In the early 1970s I started freelancing for *The New York Times*. Tom
Johnson, the *Times*'s West African bureau chief, told me about the
continuing enslavement of Africans in Mauritania. The next time I was in
Africa, I went to the Mauritanian Embassy in Dakar, Senegal, to request
a visa; I had decided to document this crime against humanity in
photographs. Like other buildings in Dakar, the embassy was surrounded
by a high perimeter wall. A man opened the gate and nodded me in. He
was older, with a distinguished face—a simple man, full of dignity.

When we reached the compound's porch, I took out my camera
and, holding it in front of me, mimed making his picture. He nodded
and smiled, acknowledging his agreement. I raised the camera to my eye
and had just started shooting when from behind me an Arab man rushed
out of the house, grabbed my arm, and shouted at me in what I realized
must be Arabic. Trying to stay calm, I told him in English I didn't
understand. I went on to tell him I was at the embassy to get a visa to
visit his country. No longer shouting but definitely still agitated, he
informed me in halting English that he was the consular officer and that
I was under arrest for photographing the old man on the grounds of the
Mauritanian Embassy without permission. Clearly the officer was not
interested in what the old man might say, and the man himself appeared
frightened.

The consular officer directed me to follow him inside to his office.
He was not to be reasoned with, so I asked him to call the American

Embassy and ask for the American consular officer, whom I had just visited there. The telephone conversation went nowhere. My warden was adamant. Even when the phone rang and the American consular officer spoke to him again, he refused to budge.

In desperation, I searched for the bridge to connect with this man. I brought up Martin Luther King and Malcolm X, but these names drew no response. It then dawned on me that the most popular Muslim in the world in the 1970s was Muhammad Ali. Speaking his name, I saw recognition. I tried to communicate how proud I was of Muhammad Ali. A big man! A big man indeed, we both agreed. In time, as our awkward conversation progressed, I drew the officer back to my original purpose and asked for the visa to Mauritania. It would take several weeks, he told me—time I didn't have. I asked if I could leave, and to my relief he nodded.

Revisiting the incident in my mind, it occurs to me that the old man might have been enslaved, brought to Senegal from Mauritania to serve in the embassy compound. The consular officer was abusive, refusing his charge even the simplest right of having his picture made. Perhaps I had found the horror that I had been told about.

Those Sticky Dates

A week before the Egyptian Air Force made a surprise attack on Israel in 1973, I was in Egypt, captivated by the Temple of Luxor. I spent those still-peaceful days in awe of Africa's ancient history. Here were towering

columns, mind-numbing in their sheer size—about six stories high, with a diameter at the top large enough to accommodate thirty people.

I decided to explore Luxor, known as Waset by ancient Africans and Thebes by the Greeks. Wandering through the town market, I made friends with an older Egyptian man named Baba. That afternoon we got acquainted in an outdoor café. Early the next morning Baba came to my hotel and invited me to have tea with him and some of his friends by the Nile River. Seated cross-legged with five Egyptian men on straw mats, I was served a small clear glass of thick, dark, sweetened tea. Then a soft brown thing about the size of a pecan was pressed into my hand. It looked and felt terribly sticky. I glanced over at the uncovered pail from which it had come and wondered how many flies had already lit there that morning. All around me my hosts were eagerly biting and sucking the flesh off a tiny seed buried deep inside these prized morsels. Figuring that since whatever this was hadn't killed them, there was a good chance it wouldn't do me in either, I bit into it; it was sweet, almost overwhelmingly sweet. The Egyptians took a sip of tea after each bite, and I followed suit. Indeed, chasing the very sweet taste with tea made it all very pleasant. Baba informed me that I had eaten a date, and he pointed at the numerous date palm trees growing along the riverbank.

Sitting on the ground sipping tea and eating dates, I imagined I had established my own bridge of trust to new friends. As I allowed myself to ease into the rhythm of that fall morning beside the Nile, I began to feel more in tune with the men beside me—and the chaotic mass of busy people and animals all around us.

The Ramesseum in Luxor, Egypt

Napoleon Rules

I was still in Luxor on October 6, 1973, when Egypt attacked Israel. The military appropriated all means of transportation, and it took me two days to secure a seat on the night train to Cairo. Once in Cairo, I discovered that the airport was closed indefinitely to civilian travel. As it turned out, I was unable to leave the country for three more weeks—a stressful time of mounting anxiety and uncertainty for all in Cairo.

There was little to do except revisit tourist sites with the other stranded foreigners. In time, though, my training in photojournalism at *Look* magazine inspired me to recognize opportunity in my situation. As far as I could ascertain, there were no other Western photographers in Egypt. The Israeli side, I knew, was being documented, but no one was recording activity on the Egyptian front.

The problem, of course, was how to get to the front and how to convince the Egyptian authorities to give me permission. I began by visiting the Egyptian Ministry of Information; the functionaries there shuttled me to the Ministry of Defense. Taxis being the best way for me to get around Cairo, I hired a driver and with his help went from one government office to the next, struggling to find a way through the maze of bureaucracy that administers Egypt.

One day, my driver and I observed the police arresting a group of young men. Not knowing their circumstances, my heart went out to them, especially after my driver remarked that it would probably be a

long time before they got out of jail. Why? I asked. What have they done? But that wasn't the point. Egypt is governed by the Napoleonic Code, my driver said. When I asked what that meant, he answered simply, "Here you're guilty until you prove you're innocent." Coming from an environment where you are, at least according to law, presumed innocent until proven guilty, I was taken by surprise.

The driver, an older man, observed my confusion with a smile. To illustrate his point, he told me a joke. During the time of President Nasser, smugglers flooded Egypt with drugs brought in by camel across the Western Desert. They would load a mother camel with drugs in Libya and let her wander back to her young in Egypt. Of course, if a drug-laden camel was discovered in the desert, the smuggler was nowhere to be found. So a law was passed. Any lone camel coming across the Western Desert was to be shot on sight.

My driver continued his story. A man sees thousands of donkeys racing toward the Libyan border. "Why are you fleeing Egypt?" he asks the donkeys. "Because President Nasser passed a law that any lone camel in the Western Desert is to be shot," comes the answer. "But," the man says, "you are donkeys, not camels." "We know," the donkeys answer, "but until it's proven, we're getting the hell out of Egypt."

We shared that brief moment of humor, my driver and I, on my quest to get to the front. It was our bridge. In time I found the right person to give me a glimpse of the war. But it was just that. I was able to photograph the victims in a hospital and a bomb crater in a town near the Suez Canal that had been bombed the day before by the Israelis, but nothing more. I was disappointed by my restricted access and doubly

disappointed when I returned home in the lack of interest in the Egyptian story by the Western press.

The Ultimate Bridge

I love people; my focus is people, and I think 90 percent of my photographs are of people. On some of my early trips to Africa, if I stayed longer than ten days in one country, I had time to develop relationships and make distinctive photographs based on mutual understanding. Inevitably people asked me to send a copy of their picture back to them. But once I returned home, the demands and distractions of my life would get in the way, and I would be overcome by guilt before I was able to afford the time and money to make and mail prints.

That was all before I traveled with a Polaroid camera. Once I discovered the immediacy of the Polaroid, I used it to erase my guilt. Now I never travel without one. The pictures are instant: back home there is nothing I need to remember to do. The very act of making the picture and having it be immediately available creates an instantaneous bridge of trust. With the Polaroids, I make gifts the recipients and their families can cherish. My pictures show the subjects how I see them— and consequently give them a tangible reason to trust me to make serious portraits with my 35mm camera.

No Crocodile

"A great tree has fallen."
"It is night."
"He has gone to the village of the royal ancestors."

So say the Asante when a member of the royal family passes. In 1999, the Asante king, the divine figurehead, passed. As soon as I heard, I made plans to return to Kumasi, Ghana, the spiritual home of this ancient African kingdom. Elaborate centuries-old traditions dictate a public funeral, coronation of a successor, and a memorial one year later for the deceased king. The last such rites took place sixty years earlier, when the just-deceased king began his reign. At my age, I feared (and hoped) the Asante people might not celebrate these grand rituals again in my lifetime.

The funeral must take place six weeks after the death of the king. His mummified body is laid on a bed made of gold; heads of state, other

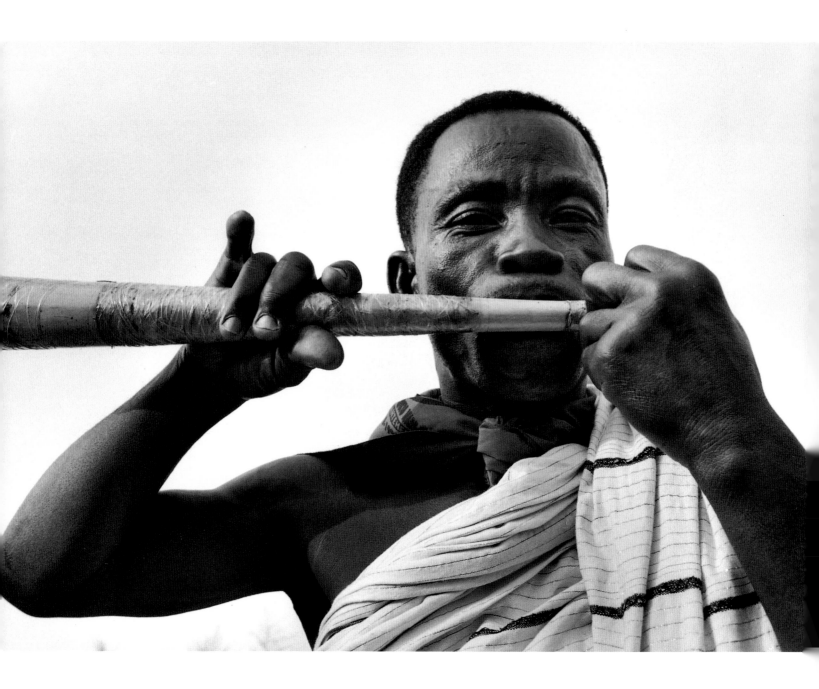

EMELDA C. AND
LA ROI MILLS

AT LEFT: AN ASANTE
ROYAL MUSICIAN IN
KUMASI, GHANA

George Cecil and Lettice
Edwards Winsor

dignitaries, and members of the Asante nation stream past to pay their last respects. At the same time, the queen mother (the nation's highest-ranking woman, usually an aunt of the king) prepares a list of possible successors for the Council of Kingmakers, which is charged with selecting the new monarch. Only royals who can trace their lineage back via their mothers to one of the three sisters of the very first king, crowned in the 1600s, when the Asante alliance was established, can be nominated for kingship. Relying on the matrilineal line eliminates succession from father to son, allowing the kingship to rotate among royal families.

In Kumasi, I went to the office of Mr. Ando, the private secretary to the king. I needed credentials to photograph in restricted areas during the ceremonies. Entering Mr. Ando's office, I barely noticed an elder couple seated side by side on a couch. I set my 35mm camera and Polaroid down on a couch opposite theirs and offered my condolences to Mr. Ando on the passing of the king. After presenting letters of introduction, I sat down to give him time to examine my documents.

Silence fell on the office. I can't recall what I was thinking, but I do remember being startled from my reverie by a gravelly voice. "Take my wife's picture," the man on the couch said to me. "She's the best wife in the world." We made eye contact, but before I could say a word, he repeated, "Take her picture; she's the best wife in the world." The woman at his side leaned into him and smiled lovingly.

It was a touching scene, but I couldn't help thinking how bad this elder's timing was. I had traveled eighteen hours and nearly six thousand

miles to document Asante ceremonies, and I desperately wanted Mr. Ando's permission. Getting the kind of access I was requesting is rare, and I wanted to concentrate on that. Now I had to decide whether to allow myself to be derailed by this extraordinary man and his incredible claim. I couldn't help wondering if my response might influence Mr. Ando's decision.

Not knowing what to do, I turned to Mr. Ando. "Uncle," I said, using the African title of respect for elder men, "is it true?"

Mr. Ando must have been listening, because he looked up at once. "We Asante have a saying," he told me. "If the frog comes up from the bottom of the river and tells us that there is no crocodile in the water, we must believe him."

I took my Polaroid in hand, knelt down in front of the elders, and began to make the woman's picture. I gave her the first Polaroid and then made another picture of the couple. They were so happy, and so, to my surprise, was I.

The encounter made me think about my own marriage and how special I think we are. I have often told Betsy that I like having her in my life so much that I look forward to growing old with her. Here before me were two people who embodied this sentiment. I witnessed what it looks like, and I was encouraged.

Mr. Ando did grant me access, even most of what I requested. But perhaps even more important, that simple moment in Kumasi changed the way I see couples. Since that time, I look for and photograph what I now call "best" couples—those who seem to have perfected the process of emotional spooning.

Johnny Frank and Varidee
Loretta Higgins Smith

184

The Coffee Ceremony

One year I celebrated the Ethiopian New Year in the ancient city of
Gondar. Ethiopians commemorate the year's beginning in September.
The year was 1995 according to the Ethiopian calendar; for us, it was
2002.

In Gondar I stayed with Betsy and Elizabeth at the Goha Hotel.
One morning I made Polaroid portraits of the women who cleaned our
room and gave them the photos. At lunch I shot the waiter and the
maitre d'. After that, just about all the staff seemed to cross my path,
each one looking more groomed than the last. I made numerous
portraits with my Polaroid. At the same time, I was able to shoot
appealing faces in which I saw dignity and character in 35mm.

On New Year's Day I was quite surprised and touched when one of
the staff invited us to share their coffee ceremony. Coffee is indigenous
to the Kaffa Province of Ethiopia, and the ceremony surrounding it is
uniquely Ethiopian and thousands of years old. Luckily, I had learned

that during the coffee ceremony, you are expected to show enthusiasm for the first cup. Otherwise the woman preparing the coffee might think you are displeased with the taste, in which case she must throw out the rest of the brew and start again.

I am not a coffee drinker. I was once, but during my college years I quite literally overdosed on caffeine and lost my taste for coffee. But growing up in Alabama had taught me the value of being polite. I knew what I had to do. Betsy and Elizabeth, consummate coffee drinkers, schooled me in two Amhara words they had already learned: *conjo buna*, which means "good coffee."

We wound our way down a back staircase into the bowels of the hotel, where the staff had already assembled for their ceremony. Everyone who wasn't at risk of being called for duty upstairs was wearing traditional Ethiopian dress. The floor was strewn with freshly cut bright green grass; we had seen women and children sitting along the roadsides selling neatly bundled bunches everywhere. The mistress of the ceremony sat behind a small brazier blazing with charcoal, heating a ceramic pot of water, a vase of delicate yellow flowers beside her— meskel flowers, which bloom only around the New Year. We joined the rest of the staff on narrow benches lining the walls. The woman at the brazier began pounding coffee beans with a pestle until they were finely ground. Using her hand, she carefully funneled the fine particles into the ceramic pot. When the mixture steamed, she poured it out into small cups. To these she added sugar—one, two, or three spoonfuls, according to individual preference. Another woman passed around the tray of steaming cups.

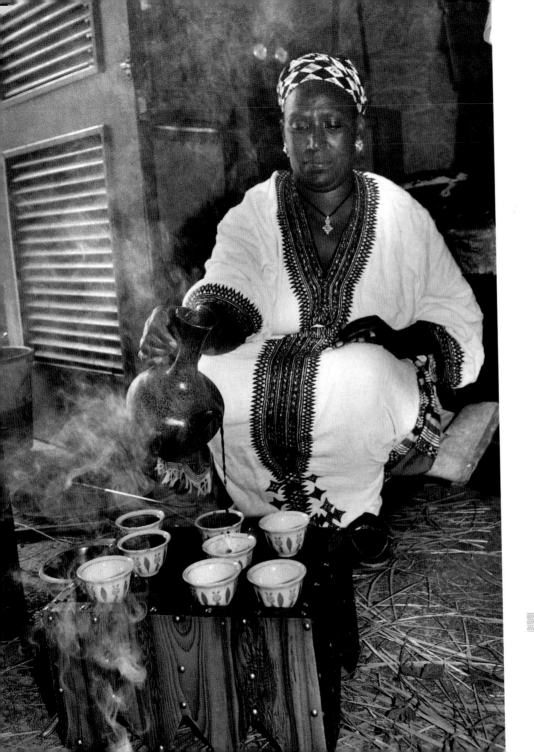

THE COFFEE CEREMONY
AT THE GOHA HOTEL,
GONDAR, ETHIOPIA

I gingerly took a cup in my hands, knowing the coffee would be too strong, bitter, and unpleasant. Holding the words I needed to say ready on my tongue, I sipped tentatively. To my surprise, the coffee was smooth and delicious. I responded with genuine feeling: *conjo buna*. My hostess, startled, smiled her appreciation, and I continued to sip until the entire cup was empty.

After the first round, our hostess brewed more coffee. She was bound by tradition to prepare three rounds. The delicious aroma of freshly brewed coffee permeated the room. I joined Betsy and Elizabeth in a second cup but declined the third. The coffee ceremony plays an important social role in Ethiopian society, and everyone in the room grew animated. We chatted, using our Amharic phrases to punctuate the accented English spoken by most of the staff.

Watching the women brew and serve the coffee transported me back to my childhood in Alabama. It was my grandmother, Faith McGowan Smith, who introduced me to coffee. Each morning her house filled with the smell of percolating "good to the last drop" Maxwell House coffee. After my grandfather left for work, Granny Faith filled her cup, placed it in a saucer, and settled down at her dining room table, where she leisurely sipped. Along with a teaspoon of sugar, she always added a little milk.

I knew she preferred to sip alone, but one morning when I was five, I decided I wanted to have coffee too. "Granny," I piped up, "can I have a cup?" I think she was afraid I would waste her precious coffee and spoil her tranquillity. She stared down her nose at me for what seemed like minutes. "You know, coffee will make you black," she answered finally.

My young mind raced to untangle her meaning. Somehow I understood, as kids often can, that her message was different from her words. She was daring me to accept my blackness. To escape racism, many black people in the 1950s wanted to lighten themselves and their children. I had often heard adults say, "If you're yellow, you're mellow. If you are brown, stick around. If you are black, get back." Even at my young age, I understood the desperation behind this sentiment. My mother's skin was a pretty coal-black color, and my grandmother's brown skin didn't show signs of darkening from drinking coffee, and in any case I was happy with the dark color I was blessed with.

I looked into my grandmother's eyes. "I don't care," I said. "I still want a cup of coffee." She lifted her small frame from her chair, using her hands, and went into the kitchen. Returning with a second cup and saucer and a spoon, she set them in front of me. With a slightly exaggerated movement, she picked up the pot and slowly poured out the hot coffee. The roasted aroma of the black beans rose up from the dark water. After she added a little milk and carefully measured in a spoonful of sugar, Granny Faith stirred my coffee.

"Okay, have some," she said, almost as an afterthought.

Slowly I began to sip the hot brew from the cup's rim. It was so good. My grandmother and I sipped and slurped together that first morning and many others after. Our relationship deepened over our shared love of coffee.

pilogue

I am the child who traverseth the road of Yesterday.

I am Today for untold nations and peoples.

I am the One who protected you for millions of years.

—from *The Book of Coming Forth,*
 Kemet (ancient Egypt)